Art
Against
Despair

The School of Life

Published in 2022 by The School of Life
First published in the USA in 2022
930 High Road, London, N12 9RT

Copyright © The School of Life 2022

Designed and typeset by Marcia Mihotich
Printed in Latvia by Livonia Print

A proportion of this book has appeared online at
www.theschooloflife.com/thebookoflife

The School of Life is a resource for helping
us understand ourselves, for improving our
relationships, our careers and our social lives
- as well as for helping us find calm and get
more out of our leisure hours. We do this
through creating films, workshops, books,
apps and gifts.

www.theschooloflife.com

ISBN 978-1-912891-90-0

10 9 8 7 6 5 4 3 2 1

FSC
www.fsc.org

MIX
Paper from
responsible sources
FSC® C002795

Art
Against
Despair

Our societies sometimes struggle with the question of what art might be for. Here the answer is simple: art is a weapon against despair.

It can be a tool with which we try to wrestle against loneliness, a sense of persecution, paranoia, fear, timidity, an impression of having been left out, rage against those who have let us down, self-contempt – and regret at how much we have misunderstood. We should hold on to it as we might to a very soft blanket or a raft.

Art is about hope when it shows us pretty and inspiring things and especially when it shows us melancholy ones: a rainy afternoon, an isolated diner, a person crying at the kitchen table, a bedroom lit up against the darkness. It provides a common juncture at which the sadness in me can, with dignity and intelligence, meet the sadness in you.

This is a portable museum dedicated to grief and courage. It has little to do with those grand national galleries of art sculpted from granite and marble where floors are dedicated to the important movements of art and where, exhausted and overwhelmed, our thoughts soon turn to the cafeteria and (with luck) cake. This is a miniature gallery of sorrow that can rest on the bedside table or the edge of the bath and is built of images curated for their capacity to shore up our moods. It is a museum for despondency that longs to slow down and on occasion reverse a slide into self-hatred and terror. It wants us to hang on and wait for dawn.

Religions knew what art was for. It had nothing to do with remembering dates or understanding techniques. It was for crying with and imploring to. It was for kneeling down in a solemn hall in front of so that Vishnu or Guanyin, Mary or Buddha could hear what was tearing us apart: that there would be no more money at the end of the month, that our partner was cold-hearted, that we had seduced the wrong person, that our children had no love in them, that we felt like a failure, that we wanted to die.

In such circumstances, it would not be at the forefront of our minds whether or not the art was 'good'. All that counted was whether it felt effective, whether it looked as if the deities understood, whether their eyes were sufficiently compassionate and their sensitivity and calm convincing. Artistic talent was strictly in the service of our souls.

We may no longer believe in gods very much, but this doesn't mean that art has abandoned its capacity to console and rescue us. Secular works of art – a careful painting of four daffodils in a jar in early April, a silvery photograph of the Sierra Nevada, an embroidered tapestry of a llama, an abstract canvas of dark blues and greens, a sketch of a sheep and its

young or a study of a river at dusk – retain a power to rescue our moods and rearrange our priorities. Culture can replace scripture.

In this portable museum, we are invited to be as emotional as we might once have felt in a temple or a church. We can fall into solemn reflection, we can cry, we can feel sorry for ourselves and we can vow to change our lives. The artists would have wanted us to do so.

It may be a time of distress right now. It might be night. We might be in a hotel, a clinic or an unheated spare bedroom. It may feel as though we are entirely alone and that no one could possibly understand. They do.

This is an alternative to despondency.

As much as pills, therapy, walks, a thoughtful friend, baths, a lot of sleep and perhaps the occasional cinnamon bun, this gallery of images is a tool in the service of our frayed psyches.

This is art against despair.

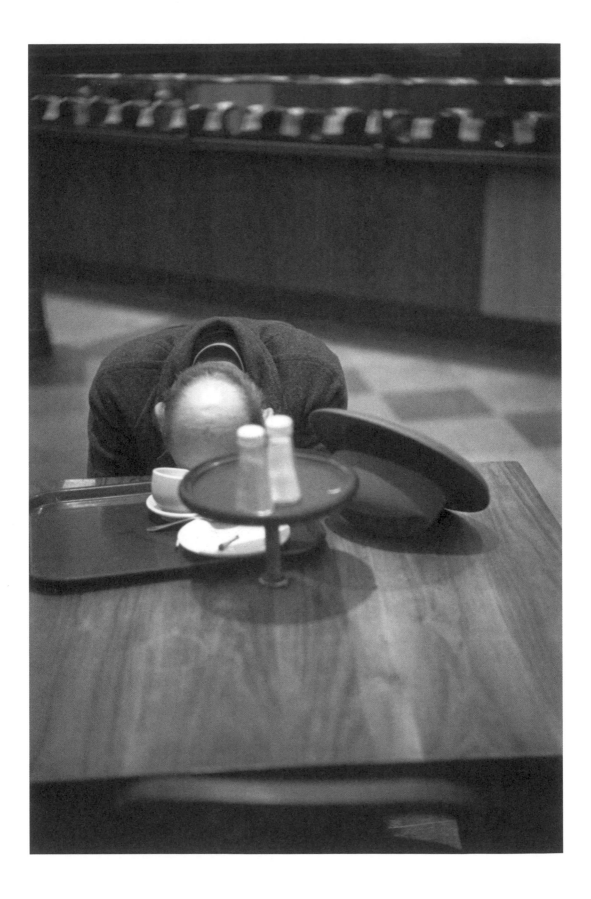

Henri Cartier-Bresson,
New York City, Brooklyn, 2nd Avenue,
A café, 1947

For a long time, he kept it together. As late as this morning, he believed it might, despite everything, be OK. He'd taken his hat along with him, as always; he remained attached to appearances. Even as his anguish mounted, he kept going, one sip of coffee after another, an occasional pat of the mouth with a paper napkin, while looking out at the busy room: secretaries out for lunch, people from the nearby construction site, a few exhausted mothers and their children. Then, suddenly, there was no arguing with the despair any longer. It swept him up without a chance of a rejoinder: the mess he had made, the fool he had become in everyone's eyes, the absurdity of everything. His head hit the table with a shocking clatter, but almost at once it was absorbed by the dense murmur of the room and the city. Someone could die in public here and few would notice.

But there was a Frenchman opposite who was very much into noticing, an elegant willowy man, with a name impossible for Americans to pronounce (he invited them to call him Harry) and a Leica 35 around his neck. Henri Cartier-Bresson had wandered the area all morning; he'd shot a group of women chatting outside on Grand Street and a view of midtown Manhattan from the promenade. Lunch was now the priority. Then, without warning, that bang of a head hitting a table.

Our reasons for despondency may be different, but we're united in how it feels: he is us and we are him. Cartier-Bresson has shot each of us and done us a great favour in the process: the distress that normally dwells painfully and privately inside our minds has been given dignified social expression. We can commune collectively around pain. We need not feel ashamed at our despair; it is an inevitable part of being alive. Whatever is sometimes implied, it is very normal to be in agony. We don't need to be brave on top of it all.

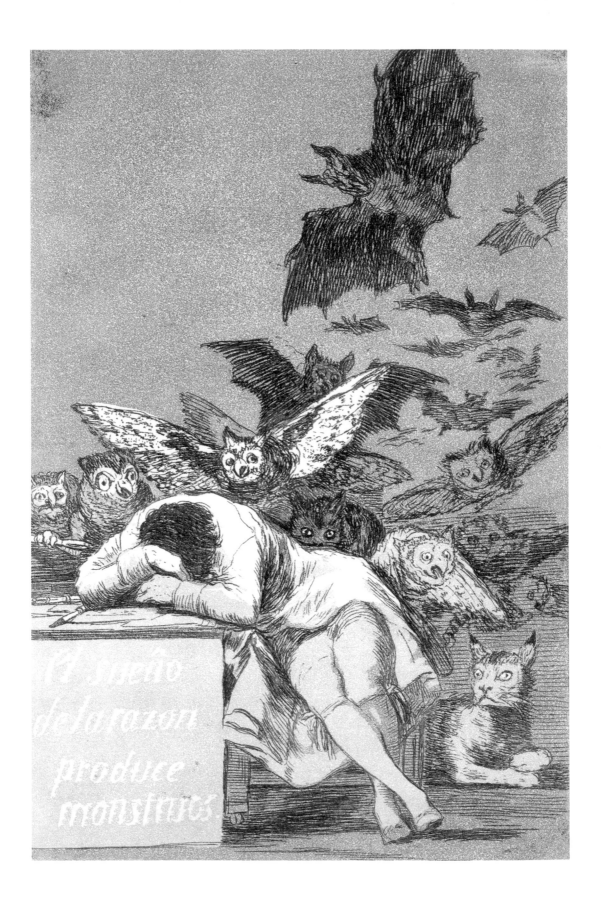

Francisco Goya,
The Sleep of Reason Produces Monsters
(no. 43), from *Los Caprichos*, 1799

The caption is keen to orient us at once. In case we were to miss it, it's even etched on the desk, and sounds yet more eloquent in Spanish: *El sueño de la razon produce monstruos*. In other words, as Goya knew intimately (he'd had bipolar disorder since late adolescence), night is when things become unbearable.

Each animal is really a thought that assails us and is trying to kill us, a thought that is probably an internalisation of the most awful messages we've ever heard from other people (probably those we grew up around): *You are no good, you disgust me, don't you dare to outsmart me.* The owl with outstretched wings is shrieking: *You will never achieve anything.* The furry beaked bat is hissing: *Your desires are revolting.* The lynx-like thing at the bottom looks on in judgement: *I'm so disappointed in what you've become.*

During the day, when we feel the monsters hovering as we talk to a colleague or give a presentation, we can fend them off with rational arguments: *Of course we've done nothing wrong. There's no reason to keep apologising; we have the right to be.* But at night, we forget all our weapons of self-defence: *Why are we still alive? Why haven't we given up yet?* We don't know what to answer any more.

To survive, we need to undertake a lengthy analysis of where each animal came from, what it feeds off, what makes it go on the prowl and how it can be wrestled into submission. One beast might have been born from our father's mouth; another from our mother's neglect. Most of them love media, too much work, exhaustion, cities and status anxiety. And they hate early nights, nature and the sweetness of friends.

We need to manage them with all the respect we owe to something that has the power to kill us. We need to build very strong cages out of solid arguments against self-loathing. The monsters will weaken with every piece of calm self-analysis until the point when, even in the dead of night, as these monsters chafe at their collars and wail while striking at their bars, we will remember enough about ourselves to be unafraid and to know that we are safe and worthy of love.

9

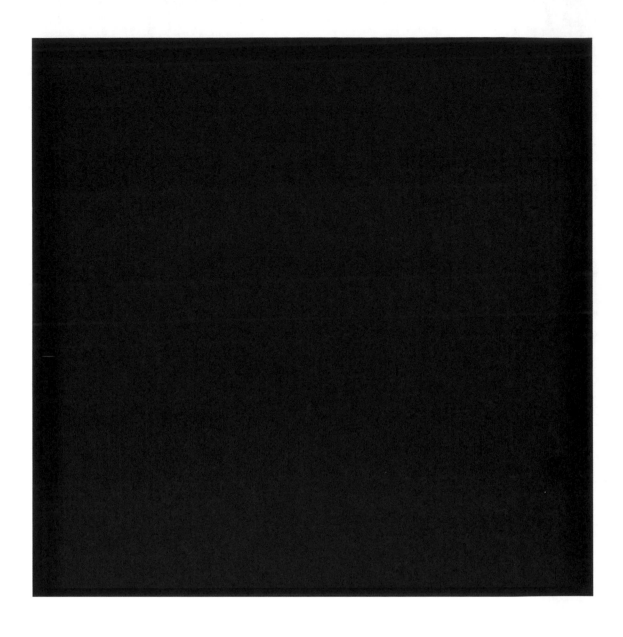

Ad Reinhardt,
Abstract Painting, 1963

For those who care about these things, Ad Reinhardt could draw very well: flowers, rivers, apples, his mother. But for the last ten years of his life, from 1957 to 1967, Reinhardt focused exclusively on a succession of large empty black canvases, which now hang in many of the world's greatest museums. When he died suddenly of a heart attack aged 53, a friend remarked that he had disappeared into his own blackness.

But Reinhardt wasn't ever just painting black. For those ready to look long enough and patiently enough, there are squares within the black squares, squares that have been elusively tinged with ever-so-slightly adulterated versions of black: black with a hint of red, black with a bit of blue, black with a suggestion of green. It takes a while for these to come to our attention; a few minutes at least, which is a long time to stand in front of a picture. 'Everything is on the move,' Reinhardt remarked, 'art should be still.'

Reinhardt detested the frenzy of modern life, especially the pressure to smile and present a cheerful busy facade. Existence for him was a tragedy and art was there to witness and reflect upon it. He wanted his work to invite contemplation of the most serious, desperate topics. And yet, despite everything, his canvases are far from gloomy. Arranged in a sequence along a large white wall, they present us with a graceful call to give up on breeziness and superficiality and make our dignified peace with solemnity and grief. We no longer have to pretend; we can dive into the darkness.

We may be ill because we have run away too fast and for too long from our grave states of mind. If we were able to sit still with them and explore them, we might discover multiple possibilities for compassion and reconsideration. There is so much lurking within the darkest aspects of our relationships, our workplace ambitions or our families. The black squares urge us to be unfrightened in the face of our regrets, our frustrated aspirations or our bitter-sweet memories. Darkness is not synonymous with nothingness; it is rich with detail and the possibility of calm, redemptive insights for those brave enough to peer at length into its depths.

LOOK AT ME . . .
I HAVE NOTHING TO HIDE

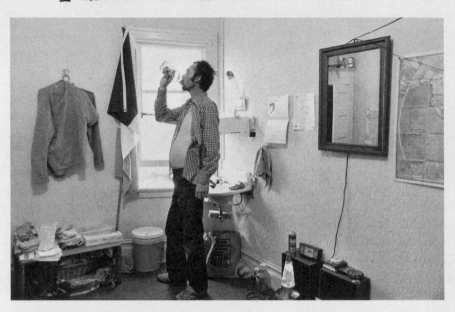

I'm FUCKIN lonely & INSECURE
I'm STUCK IN THIS Hotel
I NEED A DRINK — —
To FORGET
To MAKE ME FEEL SECURE

William H. '82

Jim Goldberg,
Untitled, 1983

Jim Goldberg had a deceptively simple idea: to make portraits of people in their bathrooms, bedrooms or front porches, then print them out in black and white with large borders, and give them back to their subjects to write down, with total honesty, how they feel about themselves. In one example, a mother and a young daughter are in a modest tidy kitchen. The caption reads: 'We look like ordinary people! We have a terrible life.' In another, a distinguished-seeming lady sits on the edge of a bed in a run-down motel: 'I will not allow this loneliness to destroy me, I STILL HAVE MY DREAMS ... Countess Vivianna de Blonville.' And then there is our man, trying to appease his self-hatred while losing his mind.

In the series, we sense the tragic irony of all the mistaken efforts we typically make to keep up appearances in the hope that this will make us acceptable and win others over. With no evil intent, but simply out of a hunger for love, we lie: we declare that we are fine, that things are on the up, that we're OK really, while inside, we long, we sob and we despair. We believe that we are doing others a favour, but we are only compounding the isolation that is killing us all. Our upbeat pronouncements serve to box everyone in; no one can find a way to commune around what are, in truth, universally distributed pains. Lies beget lies. The price of honesty becomes ever higher.

Goldberg's work tries to help us break the chain. Beneath the surface, we are all in various stages of agony, as the scrawls in the margins of his pictures attest. The visual evidence is usually slight, even nonexistent. 'He looked so happy,' they so often say of those who have recently jumped off bridges. We are ready for friendship and its consolations when we can trust that things are almost never OK for anyone.

We are lonely because we keep forgetting that while success impresses, awes and generates envy, it is only failure, vulnerability and the confession of madness and grief that draw sympathy and connect us to others. We should keep more of our desperation in view; we shouldn't just scrawl it on the edge of photos, we should intimate it to others when we next have them over for supper. Honesty about our pain is a gift, not a burden.

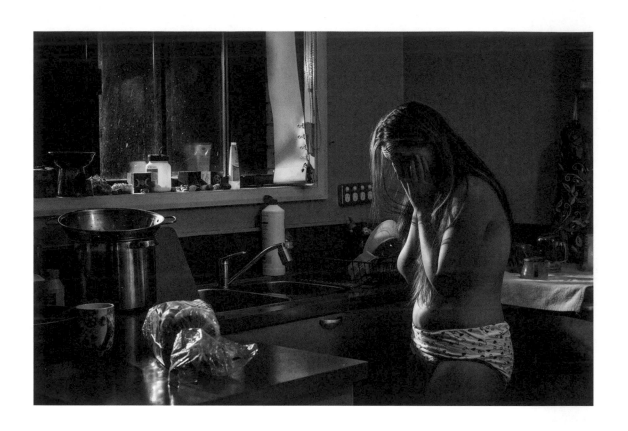

We'll never know exactly what it is that brought her to such despair, late at night, in the gloomy dark of the kitchen. But we can imagine the broad contours of her anguish because we know our own versions so intimately. She feels that no one can understand her, that her misery is shameful, that she is utterly alone and beyond sympathy.

What she can't see, perhaps, but that we might notice in the image, are the small intimations of tenderness: the moonlight lovingly silvers her arms and gently rounded stomach; her underwear is endearingly innocent and child-like; the softness of the tea towel behind her suggests the softness of the words we would, ideally, murmur. We don't see her, as she sees herself, as a worth-less failure. We see her as one of us, as broken, frail, unhappy but deeply in need, and worthy of great compassion and kindness. If only we could, and if only we knew how, we'd want her to feel how much intimate goodwill we have for her; how her unknown pain moves us.

Our closeness to her in her distress is the great message of the work. At our own lowest ebb, we think no one could ever look at our shame-ridden selves and feel genuinely close to us and powerfully and generously moved. We can't imagine someone wanting to stand by us, put their arms around us and love us more, not less, because we are so deeply unhappy. We think that our failings, errors, misfortunes and misery cast us out from the human community, which is interested only in our buoyant facade. We suppose that anyone who sees us now – even the people we're otherwise closest to – would disdain us as weak, incapable fools who deserve our troubles.

And yet, we ourselves have proved the reverse. Our brains may resist the conclusion intellectually, but we know it first hand, right here, in front of this piece of art: in most people, our distress doesn't provoke contempt, it opens their hearts and brings them, gently and quietly, to our sides.

Robert Adams,
Longmont, Colorado from *What We Bought:*
The New World, Scenes from the Denver
Metropolitan Area, 1970–1974

One of the reasons why we may suddenly break down without warning is that we have not been able to flex over the years. We have been too stoic, at great cost to ourselves. We have kept going. We have maintained our optimistic manner. We have driven for hours around the Denver metropolitan area to see our clients, stopping off for meals at unsociable times of the day and night in vast, brightly lit, air-conditioned supermarkets, where we have gone through company reports over a milkshake to the sound of price promotions and jingles.

Robert Adams' subject has been carefully placed in the middle of the photograph, at the very centre of our focal point, to underscore his significance, but he is also – purposefully – a tiny, hunched figure, a boy at a school desk, redolent of submission and impotent dutifulness. He is powerless in the face of the vast alienated supermarket and the cold, functional, commercialised modernity it represents. The picture is subtly eloquent about everything that shouldn't normally be felt in this sort of place: the extent of our pain and frustration, the scale of our longing for love and beauty, our sense of suffocation, our loneliness and exhaustion.

To stand up and to start to scream, perhaps to take off all our clothes and bang the table in rage, would only look like madness; in fact, it might be the clearest sign yet of an ongoing capacity for health. We might inconvenience other shoppers; perhaps the police would have to be called; we might end up at home lying mute in bed for weeks. The family would panic but, amidst the chaos, there would be some kind of confused bid for well-being – a desire to renegotiate the terms of life, a wish to set things up for the future on a more authentic basis.

There are versions of normality that require us to lose our minds when we consider them properly. There is little in the photograph that could rightly be counted as sane; this is a portrait of a distinctively modern kind of hell that we would have every right to protest against via outbreaks of so-called folly. Under our aegis, the man should get up and shout, 'Enough!' Sometimes, the best thing we might do to ensure our sanity is to go mad for a while.

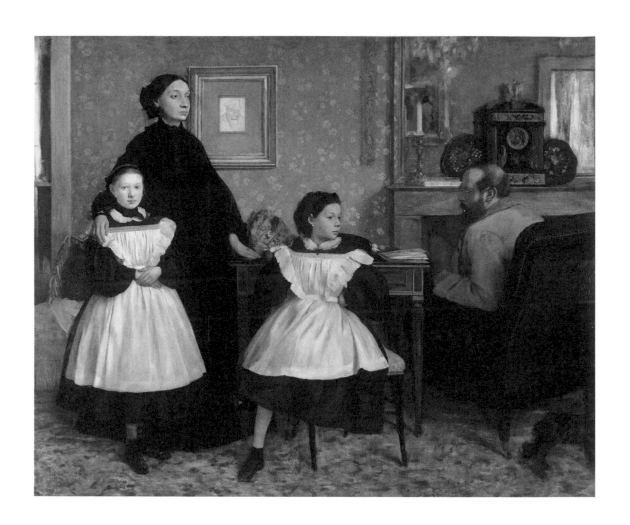

Edgar Degas,
Family Portrait, 1858–1869

The northern European mid-19th century in a luxurious bourgeois apartment; the high-water mark of not expressing feelings. It's a family portrait, traditionally the opportunity to show off our best, but Degas has done us a favour by painting that far more interesting (and common) of things: a dysfunctional family; in this case, his own. Laura, Degas' aunt, looks into the middle distance as if she were at a funeral; Baron Gennaro Bellelli, her husband, scowls with his back to us. The two children, decked out in their finest, strive to keep up appearances. A few weeks after the sitting, Laura wrote in despair to her nephew that her home was 'immensely disagreeable and dishonest … Living with Gennaro, whose detestable nature you know … will soon lead me to the grave.' We understand.

Little Giulia, with one leg tucked under, is still young enough to be playful. But the one who knows and really counts is the timid and thoughtful observer on the left, holding our gaze discreetly yet firmly; 10-year-old Giovanna, Degas' favourite cousin, whispering to us across time: *I don't know what to do. I love them, but it is awful here.*

We're usually encouraged to worry about naughty children, the ones who grow up delinquent, disobey their parents and graffiti the underpass. But we should worry as much, if not more, about overly good children, the ones who seek to please everyone and who don't know how to complain or get angry; the ones whose parents, because of their depression or fury, give them no room to rebel. They are the ones who people-please, who always assume that they are in the wrong, who invariably put their needs below those of others and who are headed for illness. They might be us.

Giovanna touches us because she is so well behaved in an environment that doesn't merit her respect. She is too keen not to rock the boat. She knows exactly what her mother – with a supervising hand on her shoulder – wants of her and how many sad things she has on her mind. She's aware how easily her father can lose his temper; furniture is regularly smashed around here. There's not much room left for her to feel or say anything.

Giovanna grew up into a sick and unhappy adult. We ourselves may have been far too good for far too long; we may have tried too hard to please and accommodate ourselves to difficult and punitive people. It might be time for us to dare to get usefully awkward for a while.

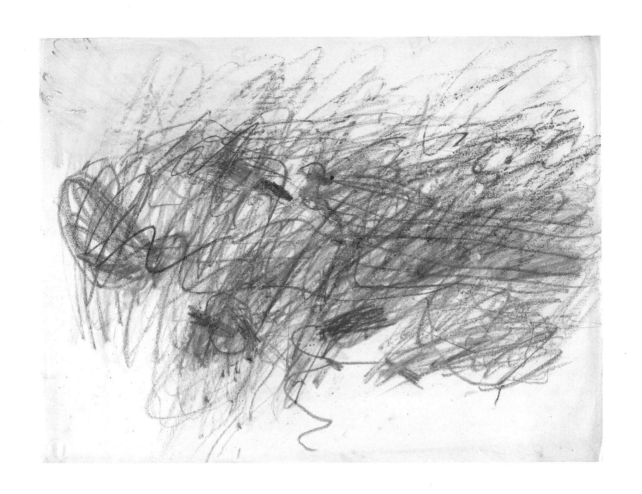

Cy Twombly,
Untitled, 1954

It's a sign of enlightenment that such works can now be taken seriously and discussed with respect; that we have collectively allowed ourselves to become aware of some of what is going on inside a vigorous scribble and all it can represent.

For most of our lives, we aren't allowed to show too much of our untrammelled selves in public. We have to speak in finished sentences and aspire to make sense. But there is so much more unfolding within. One of Twombly's goals was to give visual expression to consciousness; his subject was our inner mystery, entanglement, muted drama and lawlessness. He shows us what it is like to think and to feel a long time before we're able to produce anything as socialised as an idea or a sentence. He made maps of what goes on in the busy back room of the mind, which we rarely allow others into, let alone much acknowledge to ourselves.

The celebrated Irish novelist James Joyce had an analogous idea when he put a microphone inside his characters' heads in *Ulysses* and invited us to listen in: 'A quarter after what an unearthly hour I suppose theyre just getting up in China now combing out their pigtails for the day well soon have the nuns ringing the angelus theyve nobody coming in to spoil their sleep except an odd priest or two for his night office or the alarmlock next door at cockshout clattering the brain out of itself

let me see if I can doze off 1 2 3 4 5 what kind of flowers …'

It's far from nonsense (and it takes genius to rescue it from inattention); it's a Twombly-like meditation on the mess that happens before we can make sense to other people, before we have combed our thoughts for the world.

We usually feel obliged to edit and simplify our thoughts remorselessly. Twombly is giving space to the original mystery, to show us what happens when we aren't trying to censor and adjust to the demands of someone else. There is so much more to us than we are encouraged to realise. We should follow Twombly into the depths and hold our nerve around the mesmerising disarray. We'll be a great deal more interesting, and eventually a lot calmer, the more of the inner tumult we can bear to look at and reflect on.

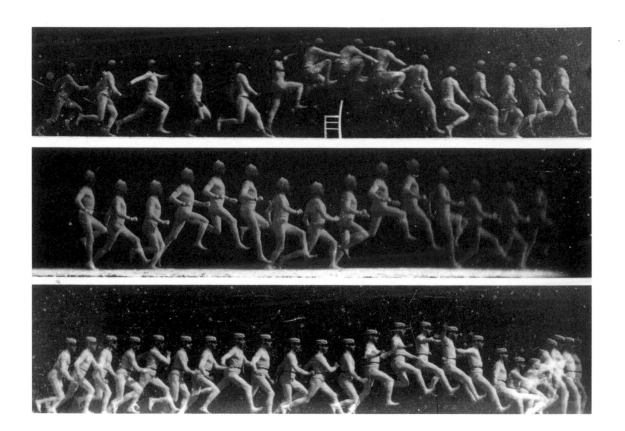

Étienne-Jules Marey,
The Running Jump, 1882

Étienne-Jules Marey was a 19th-century French pioneer of chronophotography: the art of splitting up complex movements into their parts and arranging them across a single image. After inventing a chronophotographic 'gun camera' that took twelve consecutive frames a second, Marey fixed a small piece of gold foil to a moth's wings and recorded the particular figure-of-eight shape these make when beating in flight. Then Marey became interested in birds and photographed the landing of a heron, a duck, a pelican and a seagull, before shifting to observe the motion of sheep, donkeys, molluscs, dogs, reptiles and a jellyfish he found in the Bay of Naples.

Along the way, he was able to answer for the first time the mystery of whether a galloping horse ever has four hooves off the ground at the same time (it does) and how a falling cat manages to land on its feet (it uses the inertia of its own mass, proposed Marey, thereby ending a mid-Victorian vogue for throwing cats out of windows to learn more). Shortly before he died, Marey made a landmark study of fifty-eight kinds of smoke as they blew over a variety of differently sized objects.

Marey's images of a jump remind us of our usual inability to notice more than a fraction of what is actually happening within our apparently simplest actions. Most of what we do slips through our fingers. Our blindness applies as much to the psychological realm as it does to the physical one; however complicated walking or jumping might be, nothing compares with the number of nuanced steps involved in dynamics like 'trying to get through to my child', 'breaking up with a lover' or 'searching for approval from a withholding parent'. Imagine if we were also able to break down such events into their parts.

Marey's images bid us to try to slow down time so that we can grasp more about the often pained but elusive lives we lead. Fortunately, we do have equivalents to gun cameras in the psychological sphere. They are called diaries, discussions with friends who listen well, psychotherapy sessions and long baths, all of which help us to go carefully through our emotions and tease out what is happening to us beneath our anxiety or anger, desire or guilt. The movements of our hearts are no less complex than those of a heron's wing and are as rewarding to isolate and study. Our perturbances will abate when fewer of our feelings have been left to flutter and run without exploration.

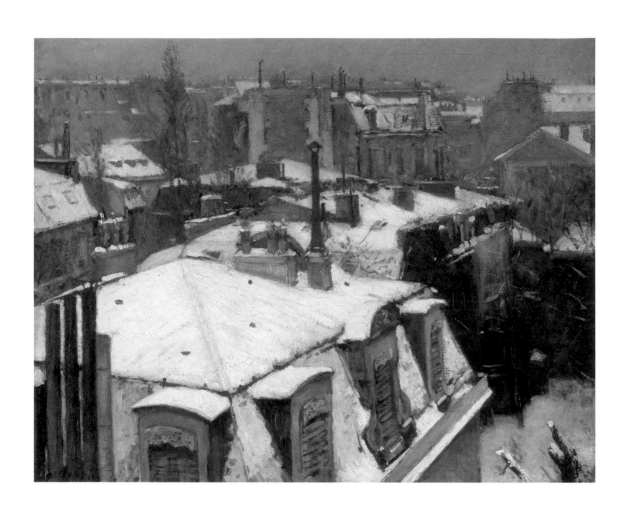

Gustave Caillebotte,
Rooftops in the Snow, 1878

When it was first exhibited, at the Fourth Impressionist Exhibition in Paris in April 1879, Caillebotte's wintry picture attracted little attention. He wasn't a famous artist and the scene was far removed from anything that, then as now, visitors would typically consider appealing: sunny vistas, bright flowers, intriguing social situations, yachts on the water.

Caillebotte had painted the picture a few months before, gazing down for long hours from a window of his top-floor apartment onto the snow-covered rooftops of the neighbouring houses after an unusually heavy fall. It's a muffled, muted scene. The leaden sky is pregnant, the air is still and cold, there are no children's cries or clatter of passing carriages. It may already be past ten but no one is heading out anywhere; the shutters in the mansard roof opposite – normally thrown open to freshen the rooms and signal the start of the day – remain asleep.

What attracted Caillebotte was the mood the view promoted. Winter is as necessary and as inevitable a part of the meteorological – and by extension psychological – cycle as other more favoured seasons. We may be more used to perceiving the value of spring, summer and autumn; these may be the staples of the artistic eye, but winter has as much to teach us. Caillebotte encourages us to make our peace with the retreat of heat and light, with the requirement to turn inward for a time, with the shortened days and weeks when, across the Île-de-France, snow blankets our usual impetuosity and enterprise.

We need periods of hibernation, when we can sit out the storms and the sadness, confident of eventually, in good time, being able to emerge revived into a less hostile climate. Caillebotte's gaze impresses us with its steadfastness; there is no need for panic or despair. There is a noble acceptance of the darkness and the bitter gusts. Best to stay inside. The earth may be hard now, but deep within its frozen particles it is already anticipating the return of the first clement winds. We should not be afraid of our sterile winter days. We can greet them with benevolence and curiosity, as they too belong to the natural cycle. However unlikely it might seem, the crocuses will re-emerge, the daffodils will in time gladden and restore us.

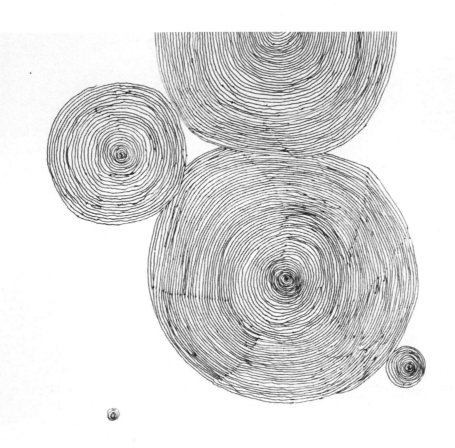

Louise Bourgeois,
The Insomnia Drawings (detail), 1994–1995

All her life, the celebrated French-American artist Louise Bourgeois had trouble sleeping. She would usually wake up at around two in the morning and not be able to get back to sleep until five. She would be haunted by memories of her domineering father; she was terrified of failure and poverty; she worried about how much she still wished to do and how little she had achieved in her own stern eyes.

Then, in the 1990s, Bourgeois – then in her 80s – decided to turn her sleepless hours to use. While still lying in bed, she created a remarkable body of work designed to steady her mind, contain her most vicious thoughts and return her to serenity and self-acceptance. She was to call these her *Insomnia Drawings*, of which there were more than 200.

What may touch us is how apparently simple they are: there are repeated lines, loops, squares, cross-hatchings and dots; there are doodles and squiggles, ears and (apparent) small feet. In order to appease her relentless mind, this hugely sophisticated, vibrant artist needed something repetitive, precise and absorbing to cling to. As she traced her red pen slowly and with an almost child-like air of concentration along the paper, another side of consciousness could set to work digesting her experiences, rearranging her sense of perspective and rebutting her fears. Insomnia was her mind's revenge for all the thoughts she had carefully omitted to have in daylight hours; now, at night, with her drawings as guard rails, she could return order to her emotions.

What Bourgeois needed in these moments of fear wasn't anything obviously sophisticated: she needed a simple way of stabilising a latent complexity that threatened to overwhelm her. When similarly vicious jumpy moods visit us, we might benefit from analogous disciplines: walking carefully around a tree, weeding a flower bed, re-arranging a cupboard or cleaning the inside of a cutlery drawer. We won't directly solve our problems, but we will still our terrors by giving our wiser, less alarmed selves a chance to return and take the reins. The apparently artless, but in truth deeply intelligent and strategic, containment of panic should be counted among the highest of our mental tasks.

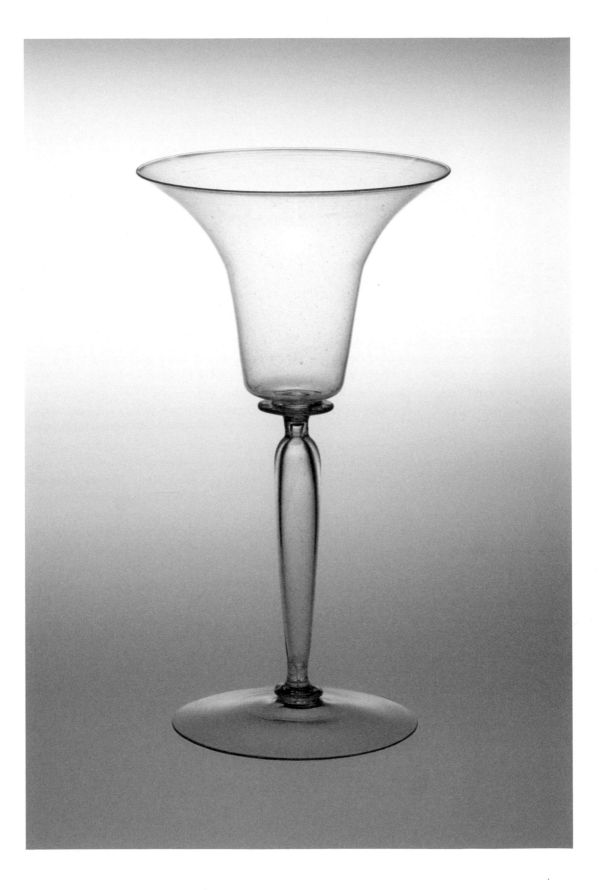

Drinking glass,
from Venice, Italy, c. 1550–1650

In the mid-15th century, a Venetian glassmaker called Angelo Barovier invented a new kind of glass, named *cristallo*, that was exceptionally clear, thin and light. It lacked the normal impurities of glass due to the addition of small amounts of manganese oxide in the firing process. It was extremely pretty to look at and also – not coincidentally – very easy to break. A few rough moves and the whole construction would be in pieces.

Most of life requires that we be strong and able to withstand the roughest kinds of handling. There is a fragile part of us, but we have to keep it hidden. However, Venetian cristallo glass doesn't apologise for its weakness. It admits its delicacy; it is confident enough to demand careful treatment; it makes the world understand that it could be easily damaged.

It is not fragile because of a deficiency or error. It's not as if its maker had been trying to make it tough and then had idiotically ended up with something a child could snap. It is easily harmed as the consequence of a devoted search for transparency and refinement and a longing to welcome sun and candlelight into its depths. Some good things have to be delicate, the glass proposes: 'I am delightful, but if you knock me about, I'll break, and that's not my fault.'

It is the duty of civilisation to allow the more delicate forms of human activity to thrive; to create environments where it is acceptable to be fragile. And we know, really, that it is not glass that most needs this care, it is ourselves.

Cristallo glass teaches us that caution should be admirable, rather than just a tedious demand; being careful should be glamorous, even fashionable. This is a moral tale about kindness, told by means of a drinking vessel.

Being mature and civilised means being aware of the effect of our strength on others. We don't need to feel ashamed if we cry easily, and we should be unembarrassed to remind others to handle us with perhaps more gentleness than they've been inclined to use to date.

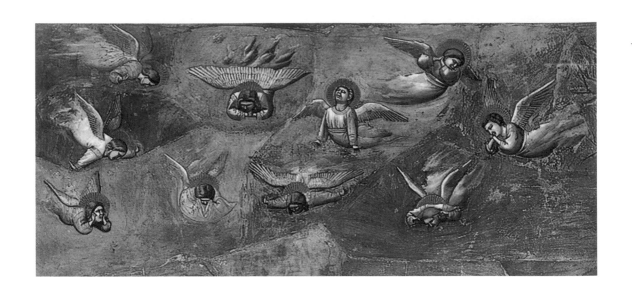

In our modern understanding of adult life, there is not much place for wailing over the woes of the world. We are supposed to leave such effusions behind in adolescence and grow inured and cynical as to the ways of our species: of course the earth is filled with horrors, naturally humans are constantly falling into distress and agony. Can we really be surprised? Do we really need to care? The more tender, generous and sadder aspects of our nature simply have to be suppressed in the name of self-possession and purposiveness. To walk down the street and weep openly out of pity for the sorrows of humanity would be considered a sign of madness.

But this respectable hard-heartedness is the opposite of the outlook sketched for us by the great early Renaissance painter Giotto when, at the start of the 1300s, he painted a fresco in the newly built Scrovegni Chapel, in Padua, Italy.

In the upper portion of the fresco, he depicts a group of child-like angels, hovering in the sky, looking down on earth, in tears. The immediate focus of their distress is a harrowing biblical moment: after his crucifixion, the dead body of Jesus is taken down from the cross and laid in his mother's arms. But the implication is much bigger: the angels are weeping for the whole of the human condition. They may have been around a long time, but they still cannot believe what they have to see. Their arms are raised in panic, they shield their eyes from yet another abomination, they call out to one another to share their wails.

Below them on earth, they see a couple screaming at one another: confused, hurt, desperate people who longed to be happy together have ended up in mutual torment. A few flaps of their wings away, they see into the secret misery of a bully, terrified of revealing anything gentle or kind about themselves. From their aerial perch, they witness the savage self-criticism that fuels a foul temper; the fears that undermine our better potential; the unvoiced apologies; the shame that makes us stilted with people we love; our hidden burdens of guilt; our immense difficulty in learning from our mistakes. From above, it may look like one long procession of folly, unkindness and regret.

The angels are not wrong. Given what we are, lamentation rather than cynicism is called for on an almost continuous basis. The angels may have seen everything, but they have not surrendered their hold on a fresh, heartbroken sense of horror at what we – and everyone else – has to go through. They have a tender lesson to teach us: that it is weeping that is sane.

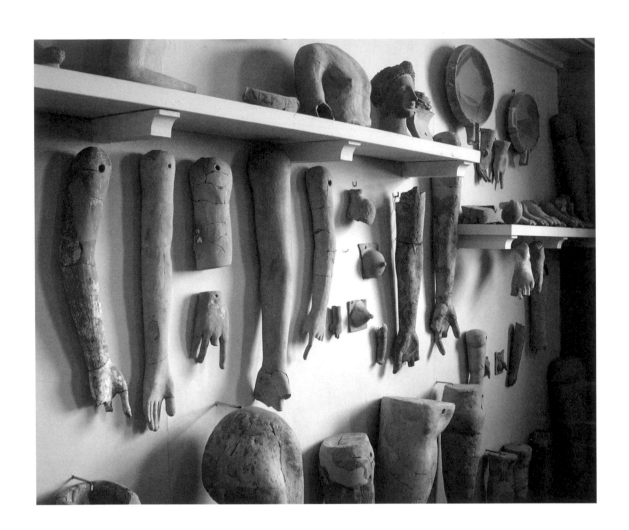

Roman votives,
2nd–3rd century BCE

In the ancient world, when someone was sick, a tradition arose of fashioning or buying ready-made pieces of terracotta sculpted to resemble the afflicted part of their body. The person would take these to a shrine, usually one devoted to Asklepios, the Greco-Roman god of medicine, make an offering, recite a prayer and then hope that the pain would subside. Tens of thousands of these Greek and Roman votives have been found, covering the range of bodily ailments: clay versions of toes, legs, thighs, bladders, colons, ears, noses, wrists, testicles and breasts. The highways of the ancient world would have been dotted with wincing people bearing, in a carefully wrapped-up bag, a clay version of an ankle, a penis or a throat.

The pieces evoke our appalling vulnerability to pains we cannot understand or contain. The peoples who invented tragedy and democracy, who built aqueducts and baths and conquered the known world were helpless before appendicitis and torn ligaments. In their suffering, they were also ready to be exceptionally credulous. But their naïvety is far from theirs alone. As children, we too make promises to the sky that, if this time Granny or Mummy is spared, we will be good for the rest of our lives. And traces of our primal religiosity pursue us deep into adulthood: *If the lights don't change before I make it across, it might not be cancer; or, the scandal may never be uncovered …*

We make pacts with imaginary figures because we too are terrified and out of control. The presence of these votive pieces rehabilitates and lends a historical perspective to our desperation. A lot that we may really want to mould into a votive isn't just physical (though it is that too); it's pieces of the internal emotional hardware that has failed us: our capacity to trust, our knowledge of how to leave a relationship gracefully, our reserves of patience, our clarity of mind. These too belong to what we might want to shape out of terracotta and place on the altar of a munificent and kindly god.

We should acknowledge the scale of our suffering and our puzzlement and render it visible to kindly others. To those who are curious, we should be able to point to a piece of sculpted clay on the bedside table or in our travel bag and declare how sick our souls are and how much we long to heal, if only Asklepios (or one of their kindly earthly associates) could listen.

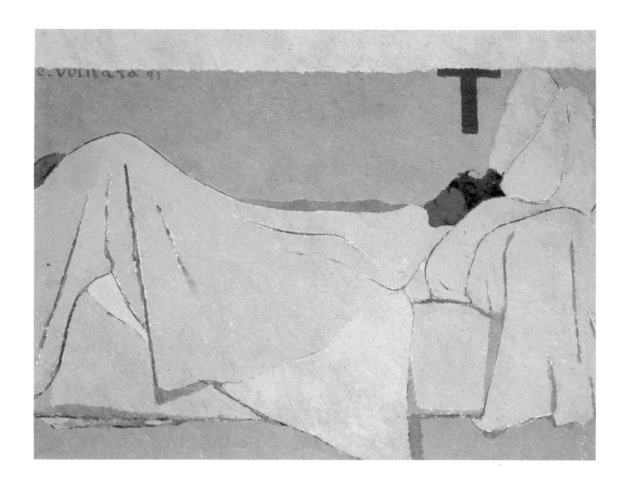

Édouard Vuillard,
In Bed, 1891

Édouard Vuillard was an unusually tender-hearted man. In much of his art, he remembers the needs of childhood that endure within the adult. It doesn't feel coincidental that he lived with his adored mother (always '*Maman*') until her death at the age of 89, by which time he was 61 (he made a total of 500 painting and pastel studies of her). His work is filled with examples of people caring for one another with kindness, of peaceful moments in domestic settings and of Maman sitting in a chair reading a book or brewing some tea. His mother kept alive in him a side that most of us – especially men – sacrifice too early, to our personal and collective cost; the side that knows how much we are crying out for reassurance, warmth and sweetness.

Also living with them in the apartment was Vuillard's sister Marie. Highly intelligent and creative, she suffered from recurring bouts of depression. She would often take to her bed, read books, say little and recover at her own pace. Vuillard catches her at one such moment; we know that she isn't actually asleep from the way her knees are up (they tend to drop down when we are), but her tightly shut eyes suggest a mood when we have had enough of trying to think and make sense of things and need merely to bathe in our confusion and misfortune for a time.

The world places us under a lot of pres-sure to leave our bed so as to produce and earn our right to exist. Mental unwellness remains hard for many people to have sympathy for. Vuillard's painting legitimates our retreat under the bedclothes (it helps that it's a surprisingly large work: 74 by 92 cm, as though Vuillard were making a deliberately public statement about the virtues of interiority).

Vuillard reminds us that there is nothing shameful about days when we cannot cope. We are better off pulling up the white flag than attempting to bury our sadness in activity. The Vuillard apartment in Paris was a cocoon of love; if someone had a sensitive stomach (as Vuillard did), someone else would prepare a vegetable broth. If someone was feeling dejected again, there was encouragement to lie down and do nothing for a while. You would be allowed not to cope, you didn't have to be strong – and hence you could thrive.

In museum galleries, alongside paintings of battles and princes, we need images that can show and lend legitimacy to those times when it is all too much, when we are revisited by our monsters and when we urgently need our beds. Maman would have understood.

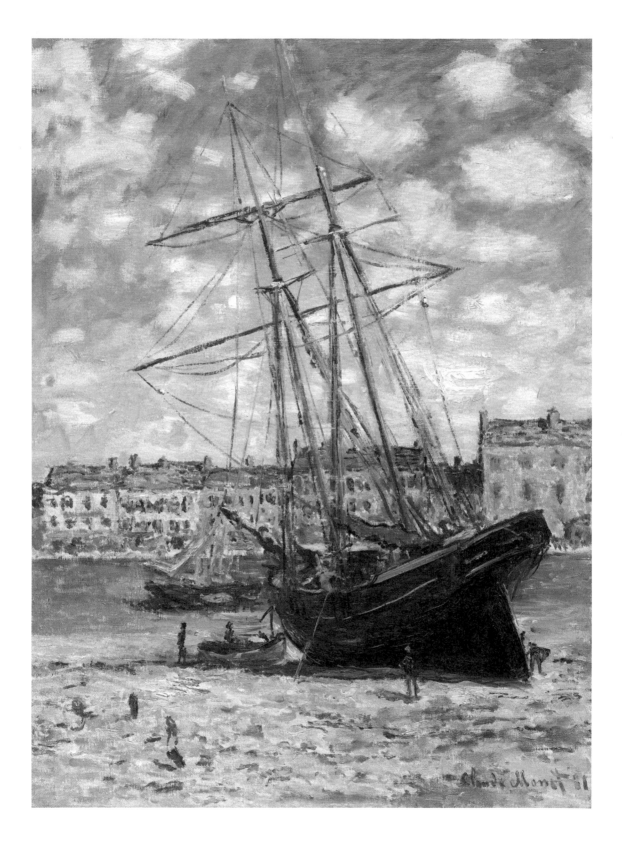

Claude Monet,
Boat at Low Tide at Fecamp, 1881

To a non-native viewer, unfamiliar with the sea and the peculiar appearance of harbours at low tide, Monet's twin-masted boat, tilted at a ridiculous angle and stranded on a shingle-and-seaweed-streaked bed on a Normandy waterfront, looks lost forever. It's good only for scrap now; its days of glory are surely over. But the truth is a lot less bleak: in a few hours the sea will come flooding back as it always does. There is nothing abnormal about a harbour in which all the boats look as if they have mysteriously been dropped on their sides in the mud. The sailors only have to be a little patient; soon they'll be underway again, heading towards the bracing brightness of the Atlantic. The impression is much worse than the reality.

Impressionism was founded on a single profound insight: the way something looks or feels (its 'impression') can be very different from the way it really is. The originating figure, and greatest exponent, of Impressionism, Claude Monet, created many images that played on this gap between reality and impression – for example, in paintings in which the immensely solid facade of a cathedral seemed to dissolve into a weightless shimmering screen of light, or in which an entire field would melt into a tapestry of flowers. Mostly he wanted to show us how apparently dreary or difficult things could reveal, through the right eyes, an exquisite and unexpected degree of hope and loveliness.

We know about the ebbs and flows of tides – we can imagine that the boat will find its way back to its original vigour – but in other areas of life, we may be less confident or patient. Our naïve early impressions can set off some unfortunate first responses: we may react at once to what our partner strikes us as saying, rather than delving into what they may actually have intended; we may give up on a task after a few minutes because it feels too hard, rather than because it is genuinely beyond our best efforts; we may dismiss someone as a bore, rather than trying to imagine our way past their shyness.

When we become good 'impressionists', we begin to learn that our immediate feelings and sensations are often only floating on the surface of things, providing scant insight into the reality of a situation, which may – as with the boat lying on its side in the mud in Fecamp Harbour – be much less stuck than it seems.

Exports and Imports of SCOTLAND to and from different parts for one Year from Christmas 1780 to Christmas 1781.

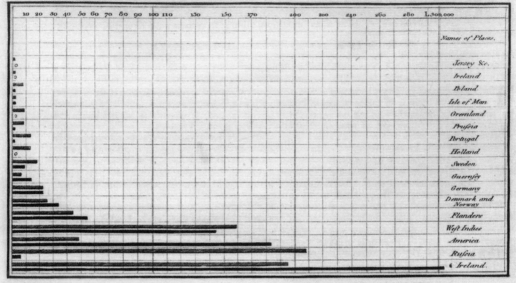

The Upright divisions are Ten Thousand Pounds each. The Black Lines are Exports the Ribbed lines Imports.

Published as the Act directs June 7th 1781 by Wm Playfair

Neele sculpt 352 Strand. London.

William Playfair,
Exports and Imports of Scotland to and from different parts for one Year from Christmas 1780 to Christmas 1781, 1786

William Playfair was an 18th-century economist who invented graphical statistics, the discipline of presenting data in visual form; he turned figures into beautiful works of art. He is particularly famous for two innovations that would go on forever to change our sense of ourselves: the bar chart and the pie chart.

Playfair's first bar chart showed exports and imports to and from Scotland between 1780 and 1781, in a way that elegantly and immediately grants us a sense of the direction of trade. His art form now helps us to absorb figures on everything from atmospheric pollution to price inflation, antibody numbers to educational scores.

But there is one area where we remain dangerously confused about how our case stands relative to the statistical norm: emotional life. Our sorrows are compounded by tendencies to exaggerate how troubled we might be relative to 'other people'. We suffer more than we should because we operate with a deeply flawed sense of how widespread our suffering might be. We add to our burden by maintaining that we must be more or less alone in finding existence intolerably difficult.

In the dead of night, we believe that no one could possibly have a partner as obtuse as the one we have landed on, that very few people would ever have relationships with their children marred by as much conflict and hysteria as ours have been, and that no sane person could be as moody and disappointed, as guilty and as shame-filled as we are. In the absence of the right sort of bar and pie charts, we insist on believing that it might be 'normal' to have a fulfilled career, 'normal' to have great sex and 'normal' to have a smiling, supportive family.

We long to have more 'normal' lives – by which we really mean, happier lives. But normality is precisely what we are likely to have already; the extent of our anxiety, regret, shame and anger probably lies almost exactly within the expected, albeit secret, parameters. Our lives may be dark, but we should never compound the pain by believing that they are also rare. We are simply, for now, while Playfair's heirs complete their work, painfully cut off from statistics about the sadder truths of others.

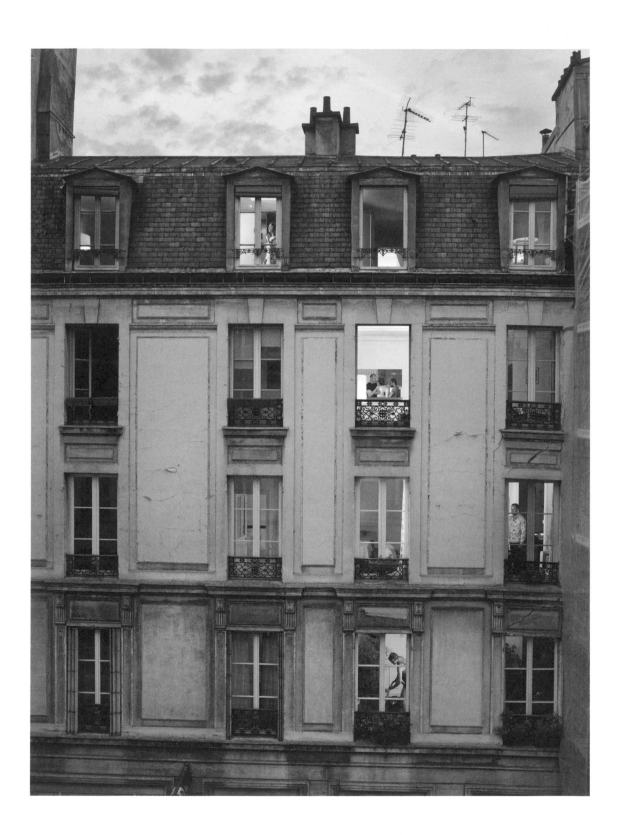

Gail Albert Halaban,
Paris, Out of My Window, 2012

Dusk on a Parisian street. In an apartment building opposite, the lights are slowly coming on. Windows that had shown only a mute greyness all day start to reveal their secrets. The opening lines to half a dozen short stories are being written across four floors. In the roof, there is someone at a desk reading a polite email explaining that they haven't, after all, secured their dream job as they had hoped. An apartment and a world away, across the landing, a woman is doing her hair or, it's hard to tell, perhaps screaming at a disappointing partner she had dreamt of growing old with. On another floor, two men are deep in conversation; they're catching up on golf, or he is explaining that he wants to leave his wife for him. A floor below there's a man standing looking oddly still and forlorn; he's wondering where he put the keys – or staring death in the face.

We can't know the details, but an overall impression emerges: we are witnessing vignettes in a unified and too seldom narrated story of the suffering of humanity. Life is difficult for everyone and yet, for arbitrary and unnecessary reasons, we live out our struggles separately, in small illuminated cages, unable to offer others the compassion and love we deeply feel and crave. We are within striking distance of major solutions, and pass them by every day in the hallway in oblivion.

Despite the isolation, the image holds out hope. If only we could look at ourselves collectively with the curiosity and generosity of spirit that inspires an artist, life would not have to be so bitter and so hard; we might be able to hold out a hand to our similarly tortured ignored fellows. The work of art may lend us the emotional impetus we need to give up on our ruinous, needless lifelong shyness.

We have only been living in our present degree of isolation for a few hundred years. For most of our collective history, we dwelt in small tightly knit groups; our species came of age around campfires. It can be the task of art to remind us that our solitude is as cruel as it is unnecessary.

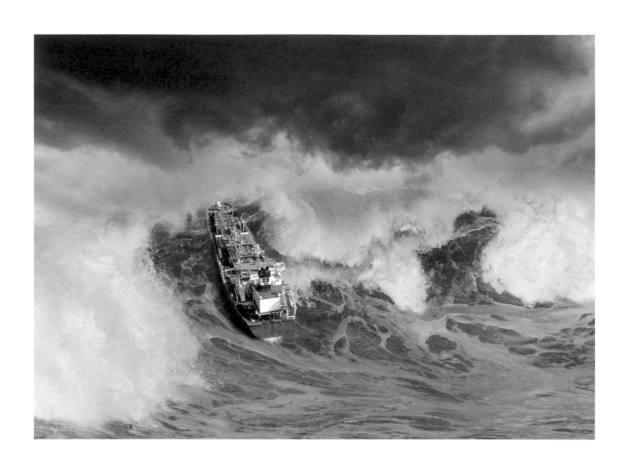

We can be forgiven for assuming that what we're looking at are the last few moments of an unfortunate ship that, moments later, was pulverised by the waves and sank to the bottom of the ocean. In fact, it was an intense but wholly ordinary typhoon that struck a Panamanian-registered oil tanker somewhere in the Andaman Sea en route from Qatar to Yokohama. It began suddenly, raged for an hour or so – then blew over. If we had been on board, the greatest surprise would have been the mood of calm. The hugely experienced, eleven-man Filipino crew had met with this and a lot worse on dozens of occasions before. There was only a need for a bit of routine caution to make sure the hatches were secured, the oil properly distributed and the tins well locked up in the kitchen. As you held on for your life and looked nauseously into a bucket, they might have slapped you on the back and said cheerfully, 'You should have seen what we went through last November off the Cape of Good Hope!'

Ships in storms have been a mainstay of art for centuries because the unruliness of the ocean provides us with a perfect metaphor for the troubles of life more broadly and because, in the calm mariner, we have an apt reminder of the attitude of self-possession and resilience we need to apply, but have such trouble holding on to, in relation to our own travails.

Most of our strategies for remaining serene are based on telling ourselves and others that bad things won't occur. But the ocean teaches us a different lesson: that it is far better to picture storms in great detail, test our power to resist them at length – and thereafter, when the winds are howling, disregard all our jittery certainties and prognoses. Our senses cannot, in the midst of a tempest, be expected to be accurate; they will be overlooking all the good reasons why we won't sink: because some clever naval engineers in Bremerhaven prepared for exactly this eventuality; because the stresses and load bearings have been carefully worked out; because we still have friends, options and creative minds; because there will be a dawn tomorrow.

There is far more strength in us than we can recall at a 45-degree angle in a typhoon. We can take a substantial amount of battering. We shouldn't get too attached to the idea of an untroubled journey; we might need to take many detours and reach harbour far later than we had hoped. But things that feel like the end usually aren't that at all. We don't break so easily.

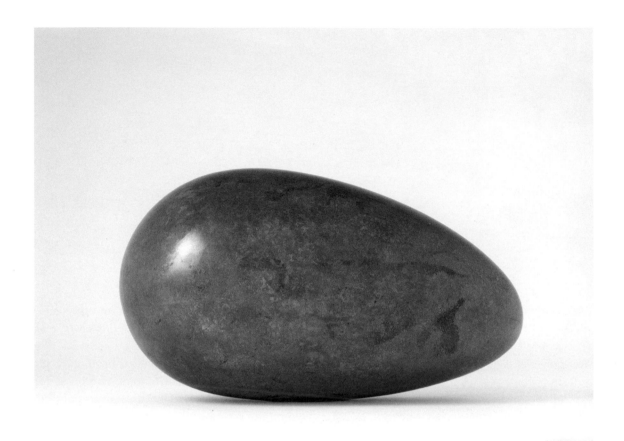

Constantin Brâncuși,
The Beginning of the World, 1924

The Romanian sculptor Constantin Brâncuși has had a whimsical, charming but essentially very serious and socially useful idea. He has re-imagined the origins of the world and posited that we might all have been born from a giant egg.

The idea is immediately sweet; human beings for their part rarely seem so. One of the reasons is that we know most people only when they are very grown-up, serious, in suits and uniforms, overalls and armour. At moments of particular impatience, it can pay to think of their origins; to remember that everyone – even the most unpleasant and stern-faced sorts – were once small delicate 'chicks' running around the living room or the garden with pieces of shell on their foreheads, defenceless, naïve and adorable.

Compassion stems from our ability to hold in mind that the difficult other was once, long ago, also a little one, and has since only imperfectly developed into an adult. The egg is the universal symbol of our forgivable origins. It comes in many forms: there's the rather grand duck egg, the familiar chicken egg, the wildly exciting dinosaur egg, the incredibly fragile and pretty quail egg or the ultra-tough ostrich egg. All these eggs are pointing us in the same direction. However different the adult appears, however aggressive, shrieking or frightening it can be, it always shared (even the Tyrannosaurus rex) the same strange, modest, endearing starting point. Not everyone's childhood was the same, but everyone was a child.

In an ideal secular religion of the future, Brâncuși's egg would be a sacred object: there might be a photo of it in every office and classroom, political leaders would kiss it on accepting office and couples would exchange replicas as they made their wedding vows. To grasp that the egg is always and necessarily our beginning is to be committed to remembering how young we all remain, how rarely we choose our defects, how fragile we all once were and still are, and therefore how much each of us deserves, as well as needs, constant doses of forgiveness, compassion and love.

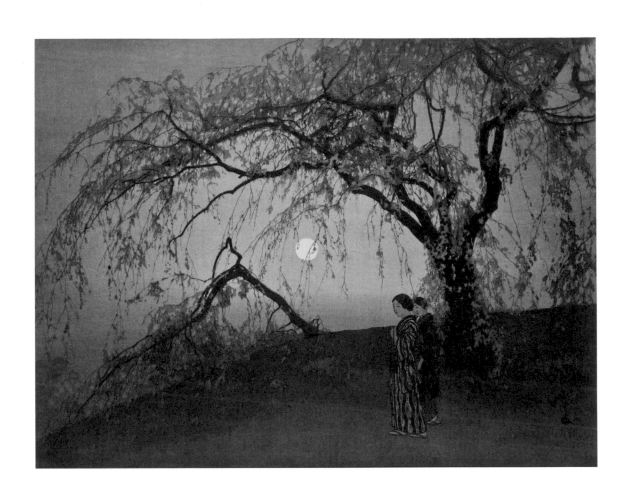

Hiroshi Yoshida,
Kumoi Cherry Trees, 1926

It is a serene night in the middle of April on Mount Yoshino, east of Osaka. Two young women, the daughters of the artist Kawai Shinzo, have gone out for *hanami*, the ritual observation of blooming flowers. A mood of quiet reflectiveness reigns. The women have dropped their voices to a whisper, better to allow nature to have its say. It is an exquisite instant, based in part on it being only an instant. Cherry trees are in bloom for no more than a week. A full moon lasts three days or, in strict terms, when the Moon is 180 degrees opposite the Sun in ecliptic longitude, only a second. Soon the women will return home to Kyoto, the season will turn and the petals will lie strewn across the mossy ground.

It has been the particular contribution of Japanese aesthetics to sensitise us to melancholy. Melancholy isn't grief or lamentation; it emerges from a wistful awareness of just how rare happiness can be and how much in life is sad and imperfect, a backdrop against which everything that remains kind, calm or graceful stands out with particular clarity.

Melancholy is a noble species of sadness built out of an awareness that life is inherently difficult for everyone and that suffering and disappointment are at the heart of human experience. It is not a disorder that needs to be cured; it is a tender-hearted, dispassionate acknowledgement of how much pain we inevitably all have to travel through.

In melancholy states, we can understand, without fury or sentimentality, that no one truly understands anyone else, that loneliness is universal and that every life has its full measure of shame and sorrow. We have not been singled out; our suffering belongs to humanity in general. It is in such states that cherry blossom will stand out with special luminosity.

Modern society is highly suspicious of melancholy, and remorselessly emphasises buoyancy and cheerfulness instead. Cherry trees know better: of course love will be brief, of course others will let us down and of course storms will blow in. None of that should surprise us. But right now it is still a beautiful spring night, Akemi and Chiyo are there to observe the scene with us and we have a few hours left to draw strength from a delicate pink mantle of blossom.

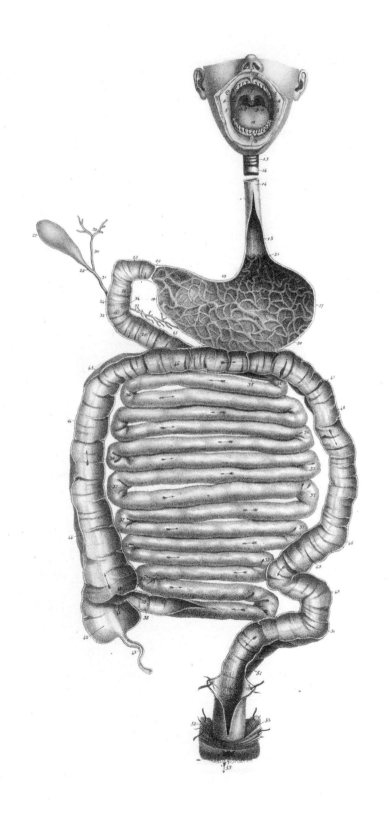

Jules Germain Cloquet,
The Digestive Tract, Plate 297 from the *Manuel
d'anatomie descriptive du corps humain*, 1825

It looks like a work of art – an early Giacometti or Bacon, perhaps – but only incidentally, which makes it all the more admirable and arresting. It was one of 300 plates in the leading atlas of anatomy of the mid-19th century, produced by the French surgeon, physician and professor Jules Germain Cloquet.

In Plate 297, Cloquet has divided the digestive tract into fifty-three sections, from the top lip (marked 1) to the anus (53), a journey of some two to three days through canals, tubes, pools of chemicals and finely engineered porous chambers, about which we are likely to know less than we do of the moons of Jupiter. Through Cloquet's illustration, we follow what we chew (known as a bolus) as it is contracted down into the stomach, turned into thick milky chime, which drops down into the duodenum and from there into the ileum, then the caecum, colon and rectum – as all the while we may have thoughts about Sanskrit philosophy or how best to style our hair.

For the layperson, the true moral of Cloquet's image is about humility. Faith in the gravity and importance of human beings cannot survive a glance at our digestive systems. Our mouths, the instrument through which we articulate our ideas and via which we communicate our most tender feelings, is ineluctably connected up to a network of foul-smelling, tightly coiled tubes. As the 16th-century French writer Michel de Montaigne sought to remind us: 'Kings and philosophers shit, and so do ladies.'

We should not berate ourselves so strongly for our failures of intelligence, dignity and seriousness. It is a miracle that we manage to have any coherent thoughts at all, let alone moments of grace, given the pestilential chemistry within. When we castigate ourselves for not being enough, we should remind ourselves of what an unlikely assemblage of tubes and sphincters we ultimately are.

'In the highest throne upon the world, we are seated – still – upon our arses,' knew Montaigne. With Cloquet's help, we can learn more precisely what that really means. If we were trying to help humans to love one another and to accept their own natures, we might do worse than begin with this modest unknowing masterpiece of art.

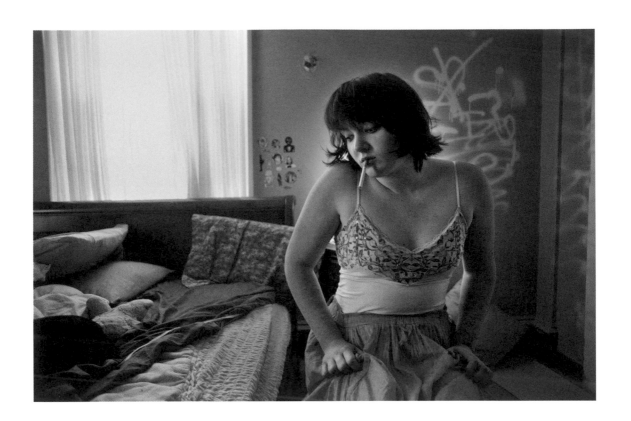

Rania Matar,
Izzy, Brookline, Massachusetts from
A Girl and Her Room, 2009

When we look at it objectively, as through the loving but steadfast lens of Rania Matar, adolescence can appear as an especially unfortunate state: the gauche bids for independence; the peculiar crushes and fads; the hair.

But in looking back at our stumbling past, we are in danger of missing an important lesson: that the process of growth should never end. We are never done with trying to be more mature and, furthermore, can never escape a degree of ridiculousness in trying to be so. We are never really adults, our follies never end and our 'adolescence' should continue until we die.

Over the decades following our teens, a range of insights might come to us. We may realise that most of the bad behaviour of other people comes down to fear and anxiety, rather than, as it is easier to presume when someone is younger, nastiness or idiocy. We may discover that we do sometimes get things wrong. With huge courage, we might take our first faltering steps towards (once in a while) apologising. We might learn to be confident by learning that everyone else is as stupid, scared and lost as we are. We could forgive our parents because we realise that they didn't put us on this earth in order to insult us; they were just painfully out of their depth and struggling with demons of their own. We might learn the virtues of being a little more

pessimistic about how things will turn out and, as a result, emerge as calmer and more forgiving. We could learn that part of what maturity involves is making peace with the stubbornly child-like bits of us that endure. We could cease trying to be a grown-up on every occasion, and when the inner 2-year-old rears its head, greet them generously and give them the attention they need.

If we are not embarrassed by who we were at 15, we have never developed. If we are not embarrassed about who we were last year, we still aren't learning enough.

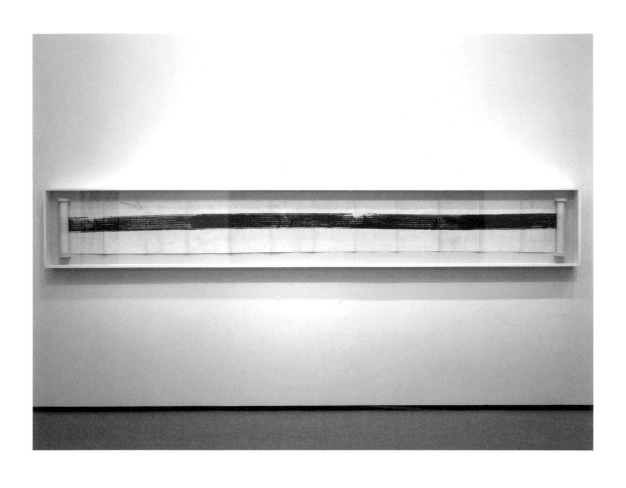

Robert Rauschenberg,
Automobile Tire Print, 1953

In dejected moods, it is easy to think of our lives as ordinary in the bad sense: banal, lacking in interest, pedestrian. We might locate glamour exclusively elsewhere: in far-off cities, places we know from magazines, the lives of astonishing strangers.

But one of art's powers is to widen our sense of what deserves to be categorised as important. It rescues us from snobbery and inattention; it reminds us that much of what is to hand is good enough already, including – maybe – ourselves. Through its prestige, it invites into the circle of rainy days, apples and pears, cans of soup, maternal tenderness, depression, blossom, and, with immense technical eloquence, insists: 'These matter too.'

Robert Rauschenberg's career was devoted to asking art to redeem ordinary life. He brought elements into museums and galleries that few had previously imagined might belong there: ironing boards, his bed, a bathtub, a stepladder, an eagle he found in a bin, socks, a stop sign. 'I really feel sorry for people who think things like soap dishes or mirrors or Coke bottles are ugly,' he said, 'because they're surrounded by things like that all day long, and it must make them miserable.'

In 1953, he laid out twenty large sheets of paper outside his Fulton Street studio in Manhattan, daubed the tyres of his Ford with paint and asked his friend John Cage to drive in a straight line over the sheets, which he then stuck together and arranged into an elegant scroll reminiscent of traditional Chinese manuscripts on which monks wrote down key tenets of Buddhism or artists illustrated the feats of emperors.

Rauschenberg was emphasising that driving a car is an astonishing proposition; by extension, much else is as well. His work amounted to a gigantic project of acceptance and rehabilitation. All our tracks are special. Jesus had reassured us that every hair on our head was numbered; that every aspect of us matters within the divine scheme. Rauschenberg – the son of Pentecostal Christians, who had wanted to be a pastor in his teens – pointed us to a similar moral. When we drive to the supermarket or pick up the children, when we are incensed and sad, when we are dejected and afraid, we have not fallen outside the circle of significance. We always remain worthy of attention and of love.

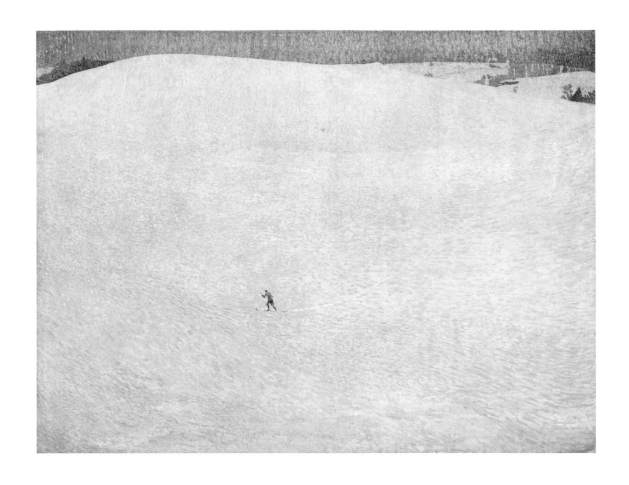

Cuno Amiet,
Snowy Landscape (Deep Winter), 1904

Some of the reason why we suffer more than we should is that we take an insufficiently heroic view of our troubles. We don't congratulate ourselves for being the resolute warriors we are. We dismiss what we have been up against in minor terms: it was just a relationship break-up, it's a passing bit of depression, it's only a change of job … Our modesty drains us of courage and self-love. Many so-called small challenges in fact require superhuman strength and fortitude; we should beware of pretending that any part of life is easier than it really is.

The Swiss artist Cuno Amiet shows us a figure battling through the snow on a hill near his home in the hamlet of Oschwand near Bern. The canvas (in the Musée d'Orsay in Paris) is enormous, 4 by 4 metres, and the figure proportionately minuscule. We can imagine the cold and the effort of moving the skis through the endless whiteness.

In the spirit of Amiet, we might benefit from adopting a more epic perspective on our own journey. Each stage might not sound so special, but we know – and deserve to feel – how hard we have had to labour. Perhaps it took us three years to extract ourselves from a dispiriting relationship, with its interminable arguments and that multitude of clever lies we had to unpick. How much we had to learn in order to be able to stand up for ourselves, which never came to us naturally. How hard we had to work to get out of a career that we had embarked on to please our parents. It took a full decade for us to understand what we wanted and to be in a position to ask for it. How bravely we had to fight against shyness in order to make the few friends we now treasure. We've been battling in the snow for a long time.

We are so used to the problem of people having too high an opinion of themselves, we forget the far more common and more dangerous obverse: those among us who can never congratulate themselves enough for what they have been through. Just being here is an unheralded, momentous feat.

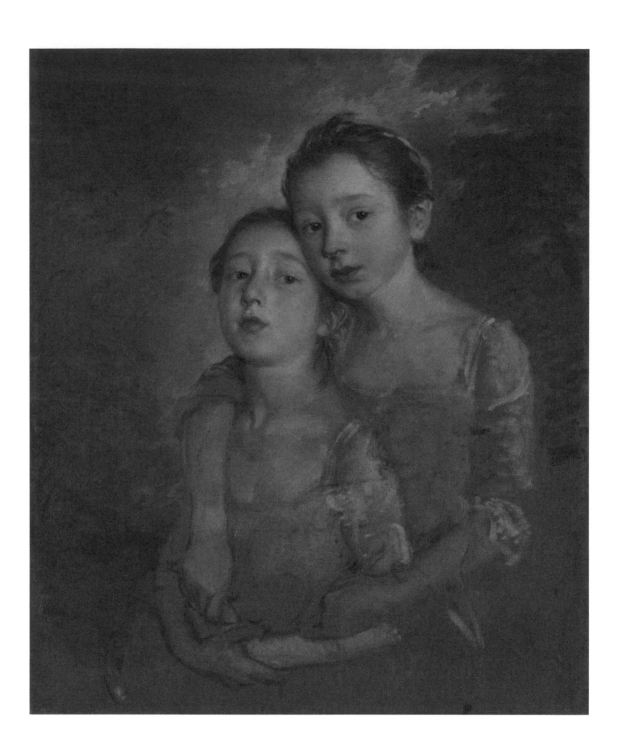

Thomas Gainsborough,
The Painter's Daughters with a Cat,
c. 1760–1761

The older we get, the harder it can be not to be intensely moved – sometimes to tears – when we come into contact with sweet things: nursery stories, lullabies, a beloved teddy or the faces of young children. We become emotional because, with age, we grow so aware of the contrast between how life generally turns out (its customary hardness, cynicism and nastiness) and the tiny islands of purity and tenderness that remain; we cry at all the lost innocence of the world.

It can be especially hard to look deep into the eyes of children: we know so much about what is likely to happen to them and they know so little. As they giggle and suggest another game on the sofa, we can only shudder at what they will have to go through before life releases them. Thomas Gainsborough painted his daughters in Bath in 1760 when Margaret (on the left) was eight and Mary (on the right) nine. They look adorable; they loved their papa, their home, their singing lessons – and the family cat. And Papa loved them back with all his heart. How cruel then to have to know the rest of the story. The little girl on the right fell seriously mentally ill in her twenties with what we would now call bipolar disorder. She made an ill-judged marriage to an arrogant musician, which lasted six months, and then, after her parents' death, moved into a house in Acton with her sister. Margaret looked after Mary day and night and was so devoted to her older sibling that she gave up any thoughts of marriage and children. When Margaret died aged 76, Mary was transferred to a bleak asylum, Blacklands House in Chelsea, where she spent her last years in lonely silence. If we had known the story from the start, it would have been hard to know where to look.

The adorable child is also us. We too deserve immense pity for what we have been through since those early wide-eyed days, and what still lies ahead. We have done nothing especially wrong; the world breaks all our hearts.

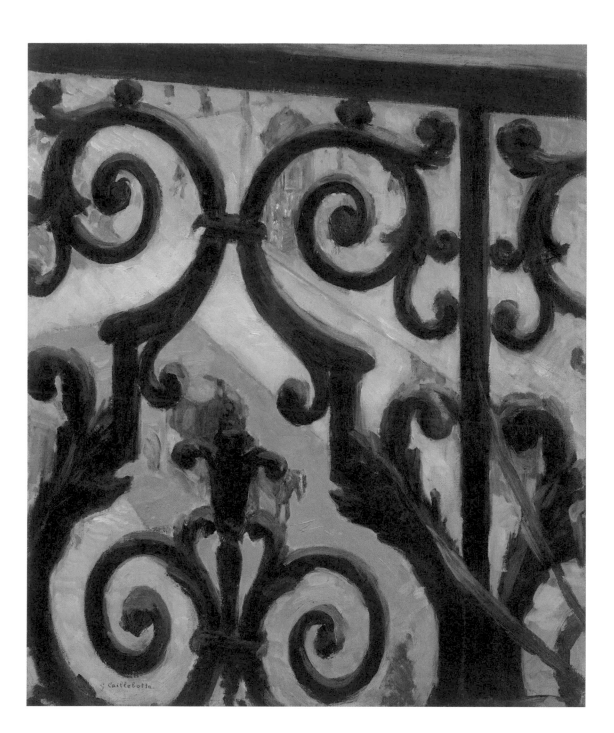

Gustave Caillebotte,
View Seen Through a Balcony, 1880

In 1879, two wealthy young men, whose late father had made a fortune supplying Napoleon's armies with bedding and uniforms, moved into a third-floor apartment at 31 Boulevard Haussmann in Paris. The older brother, Gustave Caillebotte, was to paint the view from the balcony more than a dozen times over the next few years. His real subject, on almost every occasion, was not the view itself but the act of viewing. Here, the focal point is not the boulevard – we can only just make out a horse-drawn cab and an advertising hoarding – so much as the iron balustrade that separates the observer from the world. What we are looking at is someone daydreaming; the state of detached inward concentration where our gaze is held but not detained by what lies before us while we travel through unfelt inner regions of consciousness.

We tend to reproach ourselves for gazing out of a window or balcony. We are supposed to be working and productive. It can seem almost the definition of wasted time. Yet the point of staring out of a window is not to find out what is going on outside; it is to discover the contents of our own minds.

It's easy to imagine that we know what we think, what we feel and what's going on in our heads, but we rarely do entirely. A huge amount of what makes us who we are circulates unexplored and unused; we have so many sorrows, anxieties and joys we have not yet come to know. Our potential lies untapped; it is shy and doesn't emerge under the pressure of direct questioning. If we do it right, staring out the window offers a way for us to listen out for the quieter suggestions and perspectives of our deeper selves. So much happens every day that we are unable to digest and take apart; at the window, we have a chance to understand some of the richness and resonance of what we desire and have already lived through.

Many of our greatest insights come when we stop trying to be purposeful and instead respect the creative potential of reverie. Window daydreaming is a strategic rebellion against the excessive demands of immediate pressures in favour of the hard work of charting our own unexplored emotions. 'Doing nothing' can be a very serious and necessary business.

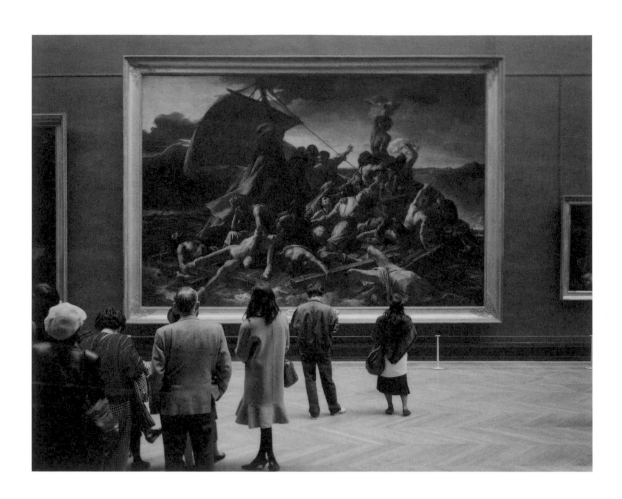

Thomas Struth,
Musée du Louvre IV, Paris, 1989, 1989

In Room 700, a vast red gallery on the first floor of the Denon Wing of the Louvre, hangs one of the most despairing pictures ever made. Painted in 1818 by the Romantic artist Théodore Géricault, it depicts a harrowing scene aboard a raft piled high with decaying corpses and the bedraggled survivors of the shipwreck of the naval frigate *Méduse*, which had run aground off the coast of Mauritania two years before. 147 people had set off on the raft; by the time they were rescued, thirteen days later, only fifteen were alive. The rest had been killed by sharks, murdered or – in several cases – eaten.

What could be the point of looking at such horror? The question is implicit in Thomas Struth's wry photograph: a handful of visitors gaze deferentially up at what guidebooks routinely describe as the greatest painting of the 19th century. We can sense reverence and – below the surface – total puzzlement. Our societies love art, but they do little to equip us with any workable sense of why it might matter.

Struth's image leaves the question hanging, but we might hazard an answer. Most of what is horrific in our world is carefully covered up – to our immense collective psychic cost. We are constantly and mistakenly forced to think of ourselves as alone with our agonies, while encouraged to smile and overlook loss, death and pain. Géricault had the courage to

give public expression to the existential horrors before us all. As the critic and historian Jules Michelet recognised: 'Our whole society is aboard that raft.' We might add: and every human clings forlornly to their own private version of a plank.

Importantly, Géricault's art enables us to experience the pain *together*. In front of a 5-by-7-metre canvas, we know that we are not alone. All the more of a pity, therefore, that Struth's visitors remain so guarded – that they might read a few banal sentences about Géricault's role in the development of Romanticism and move on. We might more fairly fall on our knees, embrace our fellow ailing raft members and cry out, 'We know!' We are all going down, ultimate rescue is impossible, but at least we can lean over and lend solace to similarly stricken beings. Art fights against despair by introducing us to – and humanising us in the eyes of – our fellow shipwrecked sailors.

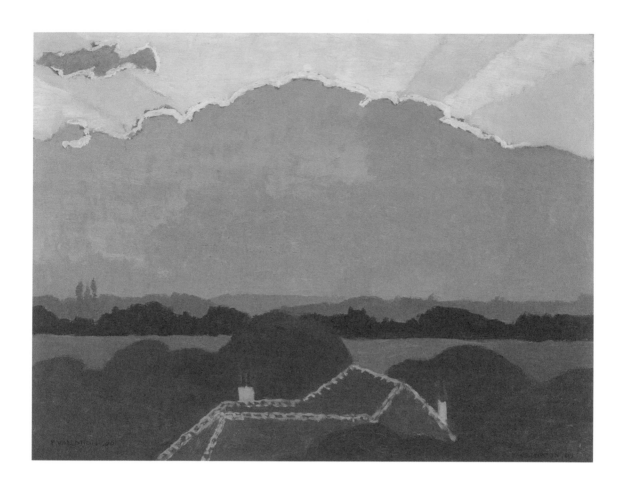

Félix Vallotton,
The Great Cloud, 1900

The 35-year-old Swiss artist Félix Vallotton spent the summer of 1900 with his wife Gabrielle in the village of Romanel, overlooking Lausanne above the lake of Geneva. One late afternoon, south-west of his house, after a dark overcast day, the dense clouds broke up to reveal a piercing, magnificent sunlight that had been lurking beyond the visual field since morning;it was a new dawn before evening, an impudent insistence on warmth and the possibility of contentment in spite of the established gloom.

The painting stands as an emblem of what a mature, wise attitude to hope might look like. Of course most of life is painful, we know that: love rarely works out, jobs are mired in frustration, friendship is largely devoid of insight or kindness, technology has fired up our worst tribal impulses. We have rendered the world ugly and frenetic. We will be lucky not to fall prey to appalling illness, scandal, romantic abandonment or insanity. The cloud cover is typically and unavoidably very thick.

But, properly aware of how much can and does go wrong, the wise are unusually alive to moments of calm and beauty, even extremely modest forms of respite, of the kind that those with grander, more naïve plans rush past. With the dangers and tragedies of existence firmly in mind, the wise can take pleasure in a single, uneventful day, or some pretty flowers growing by a brick wall, the charm of a 3-year-old playing in a garden or an evening of warm chat among a few friends. It isn't that they are naïve; precisely the opposite. Because they have seen how hard things can get, they know how to draw the full value from the peaceful and the sweet, whenever and wherever these arise.

Vallotton invites us to orient ourselves towards a new mood of mature happiness, in which the difficulties of life are firmly in our minds but don't become a lasting argument against the remaining beams of the sun. It may have rained all day, there were some tears too, but there is still time to go out for a walk before dark, around by the stream towards the forest – and maybe pick up a few pears in the orchard along the way.

Jean-Baptiste Regnault,
The Origin of Painting, 1786

A famously fanciful but telling story about the origin of painting – first put forward by the Roman historian Pliny the Elder and depicted in art hundreds of times since – explains that a young couple were very much in love; he was a shepherd, she was a milkmaid. Unfortunately, he often had to leave her to take his sheep out to graze for weeks at a time – so, in order to soften her sadness, the woman made a line drawing of the outline of her beloved using a charred stick traced against the side of a tomb. Thus art was born: out of fear of, and grief at, forgetting.

However psychologically plausible the tale might be, we might still wonder what the point of art could be for us, given that we're unlikely to find depictions of our lovers (or anyone else we know and care about) in the average museum. What is art meant to remind us of? What important things are we so at risk of forgetting that art could help to keep in our minds?

If we can answer such questions in an odd and stark way, art is there to evoke what the value of life might be; it is there to remind us of reasons to live. Most of the time, we have no need to go in search of anything as concrete as 'reasons to live', we just intuitively know that we are happy to be alive. But at other, sadder moments, life becomes a much more questionable and unworthy business.

The world grows drained of colour and existence feels bland and pointless. We lie in bed unable to think of a single reason why we would ever rise.

It is then that art can be of special use, for it can single out for us elements that remain particularly valuable and worthy of enthusiasm. It turns clichés back into their original pulsing forces: we remember how we long for the open air or how much we would like to leave the city or make time for stillness, playfulness, reading or a jar of daisies. Good art is a subtle souvenir, using its technical genius to help us recall reasons why we should, despite everything, endure.

Gwen John,
A Corner of the Artist's Room in Paris,
1907–1909

Gwen John made a memorial to the quiet life. It stands in relation to such a life as paintings of Napoleon on his horse do to a military one: it evokes; it concentrates enthusiasm; it enables us to stabilise and contemplate what we have always admired but allowed ourselves to overlook; it readies us to reorient our lives.

John lived in a small apartment on the upper floor of 87 rue du Cherche-Midi in Paris between 1907 and 1909. She painted the front room dozens of times in different lights and from different angles, presenting it as a shrine to her philosophy of integrity, quiet and tenderness.

We are given no end of encouragement to lead noisy lives. There is always a new place we are meant to discover, a new kind of career we are supposed to aspire to, a better relationship we should go in search of. John will have none of it. Our real duty is to stay put and open our eyes to the beauty of all that we have already seen but not yet properly noticed.

The highlight of a day well spent will be to go down to the bakery on the corner, perhaps for a leek tart or some bread and cheese. Then we'll return, lie on the bed and write a few things down in a notebook. There is an infinity of thoughts that we still need to work our way through and that we have not yet properly taken apart. It sounds like a life for the defeated but really it is a prescription for sanity and contentment.

A few streets away from John's apartment, several centuries before in the 1600s, French mathematician, physicist, inventor, philosopher and writer Blaise Pascal had written one of the most resonant lines in the history of thought: 'All of man's unhappiness stems from his inability to stay alone in his room.' John is entirely aware of this. This room, into which we've never been and yet we somehow know so well, is our true home that we have fatefully allowed ourselves to drift far away from through vanity and weakness. We will have reached our goal – and finally understood our destination – the more we can return here and contemplate, without distraction or self-loathing, those quiet flowers that have been waiting for us on the table all this while.

Peder Severin Krøyer,
Roses, 1893

This is the kind of picture that sometimes worries educated people because it has such immediate appeal to those who don't identify themselves as experts (and generally understand much more than those who say they are).

It is worrying because it appears as though loving this must mean having lost touch with important aspects of reality: this is not what life is really like, the experts would want to tell Peder Severin Krøyer across a century of bloodshed and cruelty. We need to remember the bombs, the scandals in parliament, the appalling problems of homelessness, cancer, the widespread nature of mental illness …

But in truth, those who are moved by the picture are unlikely to have forgotten such problems for even a moment. In fact, it's precisely because we're so aware of all the ways in which hatred and cruelty have the upper hand that we may be stirred by a work where beauty and goodness triumph for once.

The scene is unlikely to last long. Those flowers will burn up in the summer sun, flies will appear, the woman will get restless, her partner will prove an irritant and the children will be fighting and calling for help inside. But all the more reason why this instant, arrested from the torrent of dramatic events through the sieve of art, matters. Far from naïvety, it is precisely a background of suffering that lends intensity and dignity to our engagement with hopeful cultural works.

Almost no one is in danger of taking too rosy a view of their lives, or of the world in general. Rather than requiring constant doses of disenchantment, we need art that can feed and sustain our beleaguered optimism: we need to fix summer and sunshine more solidly in our minds.

This leads us to an odd conclusion: if normal life were to become consistently delightful for us, we would no longer need – and no longer have a taste for – sweetly charming, hope-inducing works of art. But until such a day, we can have a clear conscience about drawing all the pleasure we can from art that would look pleasing on the top of a box of chocolates.

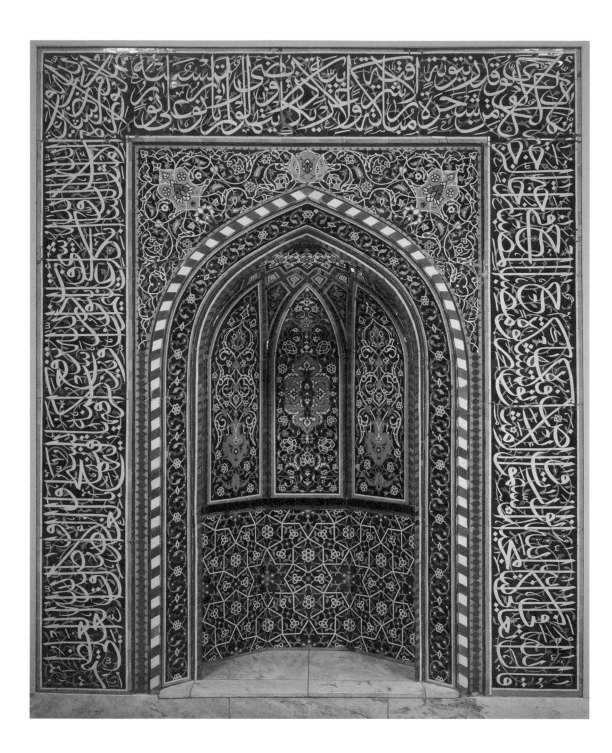

Prayer niche (mihrab),
from Isfahan, Iran, c. 1500s;
now in the Cleveland Museum of Art

A mihrab is a richly decorated opening in an inner wall of a mosque that, wherever in the world the mosque happens to be, is oriented towards Mecca. It is typically the most elaborate and beautiful part of the interior, surrounded by majestic frames of lustrous, coolly coloured tiles set in a refined abstract pattern and endowed with elegantly pointed arches and uplifting inscriptions from the Koran (here we read: 'Allah is the light of the Heavens and the Earth, His light is like a niche in which there is a lamp'). Visitors will be in no doubt that this is a place to which we need to pay attention. Art lends importance, honour and solemnity to what must not be overlooked.

When, in the early 1960s, at a time of political upheaval, this mihrab was extracted by a leading firm of Iranian art dealers from the wall of a mosque in Isfahan and sold to a museum in Ohio, the niche took on a new and wider meaning. It now illuminates a fundamental problem in all of our lives.

Our societies are bad at framing what actually matters: they typically direct prestige away from what is genuinely important and towards what are often the most trivial or demeaning reference points. A billboard of a Cola bottle might loom so large on the horizon that it intrudes on us during a funeral; in a magazine, a modish watch or shoe might be accorded more attention than a poem or a psychological truth. Advertising agencies ensure that much that we long to forget and have no use for never slips from our minds.

Art can serve as a counterweight to this distraction. Its noblest mission is to place a suitably impressive and enticing frame around all that is currently underrated and yet to which we are theoretically devoted.

Metaphorically, art is able to put blue-green tiles, sinuous arches and encouraging inscriptions around an appreciation of daily life, around a wonder of nature, around conversations where people listen intelligently, around conceding with grace, around heartfelt apologies and around forgiveness and humility. The goal of beauty is to make what is good strike us as fascinating and worthy and so to strengthen our fragile hold on our better natures. We need our own versions of mihrabs not to orient us to Mecca, but to keep pulling us back to the emotional destinations we revere in our hearts.

William Scott,
Still Life, 1973

There is a dread that we normally keep at the far edges of our minds but that occasionally floods our thoughts, particularly at 3 a.m. on a restless night: if we don't constantly strive to achieve, if we slip up or if some new catastrophe strikes the economy, we'll lose nearly everything and end up living in a tiny one-room flat or a caravan in the middle of nowhere.

The bleakness of the image spurs us to ever more frantic efforts. We'd settle for almost anything to avoid it: oppressively long working hours; a job that holds no interest; risky money-making schemes. Simplicity is a symbol of disaster and humiliation.

But through William Scott's eyes, it emerges as anything but. If we take the message of his paintings to heart, we may have to rethink our entire value system. Scott may not have written any socio-economic works, but he didn't need to; his paintings are eloquent enough on this score. Across a great number of still lives made between the early 1950s and the late 1970s, Scott explored the allure that could be found in the most readily available interiors. He painted the simplest things: a few eggs by a stove, some pears, a couple of mackerel. The plates and pans are often a bit wonky, the colours are child-like, the lines unsteady. These are among the most delightful works of art ever made.

We tend to assume that beauty has to be the outcome of immense wealth. This is the entire premise of consumer society. But expensive things are often just the most obvious and not the most imaginative instances of beauty. As our taste becomes more sensitive and our imagination more expansive, the link with money falls away, because many truly lovely sights are readily available almost everywhere on a restricted budget to those who know how to look.

With a sensitive eye, Scott discovered endless sources of everyday beauty. All were cheap. He whispers to us that we don't need to be afraid of simplicity. What we need, and what could delight us, will always remain available now that we know how to use our eyes. We can afford to be a great deal less afraid.

Daniel Spoerri,
Variations d'un petit déjeuner, 1966

Daniel Spoerri loved putting his breakfast on the wall. Also lunches and dinners of all kinds: simple ones, complicated ones, ones with six or seven guests, a few times ones with twenty or more friends who had stayed up late to celebrate a birthday (the whole table made it on the wall). He stuck up the cakes he'd eaten, the remains of omelettes, steaks and lots of vegetables. A few times he put up what he happened to be reading as he ate: German novels and Swiss newspapers especially.

It's child-like and charming. We can picture how the thought process might have gone: imagine if we took a mealtime that might have disappeared within five minutes and made it last decades. Imagine if we didn't even bother to paint things or photograph them but stuck the actual stuff right on (with invisible extra-strong glue), perhaps because we can't paint in the first place or because we want to emphasise in the starkest terms that reality deserves love. Not just poshed-up reality that has been through the filter of someone who studied at art school for five years, but actual reality, your actual teapot with its stains and marks, and your cigarettes and your bread and butter and your little tub of Hero blackberry jam.

We nominally live in democracies, where each citizen's voice is equal to that of every other. But the deepest lessons of democracy have not seeped into our souls. We remain rigidly hierarchical and blind when it comes to evaluating who and what is worthy of honour. Our eyes are perpetually pulled away from our circumstances: towards those ski boots, that bar in Auckland, that new hairstyle of an actor. Self-disdain is the norm.

The delight we might feel in the presence of a Spoerri is based on sombre foundations. We know confusedly that he is being a little naughty. That's why we want to giggle; we know he is subverting something (though we might not be able to say precisely what), because of how often we have been told that people like us don't matter very much.

There is wonder and grace everywhere, Spoerri's breakfast tells us. You might have had the vote a few generations ago; now you can have what the vote really means: dignity. The most important moments of life might be unfolding as you butter your bread. Spoerri belongs to that vast democratic artistic experiment that keeps inviting us to rediscover our circumstances and surprise ourselves with the value of a life we have been brought up to disdain.

Wayne Thiebaud,
Cakes, 1963

Wayne Thiebaud isn't being sarcastic or sly. This isn't a sophisticated mockery of ordinary appetites, or a nod to Pop art (a movement he disliked). He just adored confectionery. His mother had been a great baker and he was an excellent cook himself. When he went to Paris, his first destinations were not the Louvre or the Jeu de Paume, but patisseries and tea houses such as Stohrer and Angelina; his favourite works were not Rembrandts and Van Goghs, but cannelés and brioches, eclairs and rose des sables. Across a long career, he painted German chocolate cakes and king cakes, devil's food cake and baked Alaskas. He took us into the delights of buckeyes and Indiana sugar cream pies, banana puddings and snickerdoodles. In his 1963 *Cakes*, his precise and frank brushwork conjured up meringue and cream, icing sugar and melted chocolate, Boston cream pie and chocolate layer cake, angel food cake and strawberry birthday cake.

When lying on our deathbeds, there will really be only two lovely things we remember and wish we had had more of. The other one is cakes. Our large and sophisticated brains do us a disservice; they lead us to forget how much the central pleasures of life do not originate in their folds, and they downplay how much fun will ultimately need to come from elsewhere.

We are understandably wary of escapism. We like our pleasures to be allied to grand, rationally founded and enduring schemes: marriage and professional advancement, children and local politics. It appears demeaning to ask confectionery to provide us with one of the central constituents of the meaning of existence. But we are thereby doing ourselves a grave disservice. Most of what we scheme for in our clever minds will not come off; most of our sober larger hopes will not be realised. Friends will let us down, love will disappoint, careers will falter.

Thiebaud's art knows as much – and our stomachs concur. It is a superior form of intelligence to know the limits of intelligence; part of good thinking involves knowing when to stop thinking. To overlook the role of millefeuilles and strawberry tartlets in underpinning contentment is a cold-hearted and senseless omission. Great artists have always remembered to celebrate the real reasons to keep living.

Stephen Shore,
Breakfast, Trail's End Restaurant, Kanab,
Utah, August 10, 1973, 1973

Between 1973 and 1979, Stephen Shore made six trips across the United States, clocking up tens of thousands of miles along the way. What the photographer wanted to capture through his lens was the idea of 'America', in all its troubled glory, alienation, beauty and horror. There were to be hundreds of pictures, many of them iconic.

Perhaps his most resonant and incidentally central image was taken by chance in the tiny town of Kanab in southern Utah in a diner (that still exists) early one summer morning in 1973. Sitting in the Trail's End Restaurant contemplating his just-arrived order of a plate of stacked pancakes lathered with foamy butter, a brimful glass of cold milk and a shiny cantaloupe melon, Shore was struck by the sheer beauty and ecstasy of it all and, in a state of delight – with the manager's permission – stood up on a chair, pointed his 35 mm Leica downwards and captured an enduring testament to the pleasures of sensory life.

It doesn't feel coincidental that Shore was on a long journey and that he was in search of something large and intangible. In this respect, most of us are a version of him – though our destinations have names like 'contentment' and 'achievement'. We dream of reaching a promised land where anxiety, restless questioning and uncertainty will be at an end.

But we will, of course, never arrive. There is no true destination and there is definitely no end point. All we have is the journey – an idea that, though it has its tragic dimension, liberates us to make more of the true valuable increments of life: moments.

Without any promised land, there will be unexpected moments of pure joy, instances of total, albeit fleeting, wonder. Our happiness must be counted in minutes, not years. But when those moments sneak up on us, we should be wise enough and old enough to embrace them as avidly as a child might, push back our chair, behold them with awe – and fix them forever in memory.

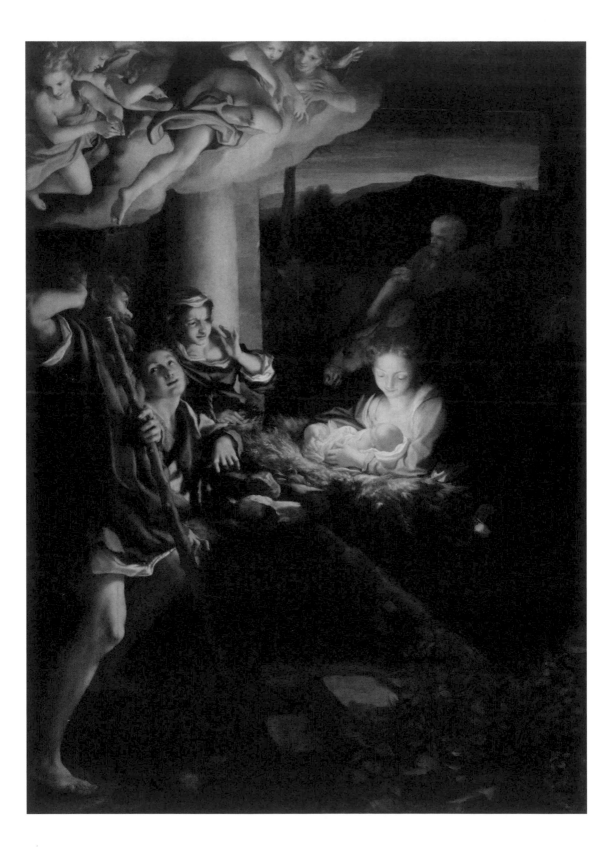

Antonio da Correggio,
The Holy Night, c. 1528–1530

He was acclaimed as the great master of light. He could do misty dawns, the warm glow of candles and the last rays of the day like no other Italian painter of his generation. Still, even Correggio's patrons in the Church were awed when, in 1530, he unveiled a work that he had been building up to all his life. Angels look on as a beatific Mary beholds the divine child, illuminated by a light emanating mysteriously from an invisible source. She may be cradling the redeemer of humankind, but her role in the cosmic scheme has not prevented her from falling in love with an exceptionally sweet bundle, whom we might want to bend down and kiss ourselves. Around her, a group of shepherds share her joy; in the background, Joseph tends to a braying donkey.

It was one of the strokes of genius and perhaps the most central idea in the whole of Christian theology that the son of God should have been born in a barn. Every great religion until then had intimated a lofty beginning for its deities; they were born in palaces, they were the offspring of kings, they made others tremble. But Christianity had a better idea. The specialness of its divine figure would be demonstrated not by signs of elevation but by his willing involvement in every conceivable aspect of ordinariness. He was exalted – and uncommonly wise and kind – precisely because he began in an inn, helped his mother clean out the yard and earned his living making tables and chairs.

Through such willing engagement with the everyday, Christianity bridged the gulf between holiness and our own existence. We were not to think of ourselves as irredeemably cut off from love and dignity. Ordinary life was itself blessed. It is, more than any other profession, artists who keep making this point for us – and need to keep making it because of how easily we forget it. What is valuable doesn't exist in a closed-off alternative world. The glow of grace follows us everywhere. It is present right now in our inns, bedrooms, launderettes, day-care centres and retail parks – for those willing to perceive its light.

John Ruskin,
*Enlarged Studies of the Feathers of a
Kingfisher's Wing and Head, and a Study of a
Group of the Wing Feathers, real size*, c. 1871

After the admiration, the next response to John Ruskin's precise study of the feathers of a kingfisher might be embarrassment – true reproachful embarrassment at the sheer boundlessness of our customary self-absorption and egoism, at just how much of the world around us the vain and empty chatter and turmoil inside our minds have cut us off from over long years.

We have failed to notice the sunlight and the water, our beloved's hands and the smiles of our children, the cries of owls and the claims of strangers. We have worried incessantly about our careers: in a rocky headland overlooking the ocean, a substantial part of our intelligence remained at the office, wondering how we might push a project forward that would get us adequately admired and promoted in the next quarter. We have fretted over our standing as a 5-year-old child attempted to explain their ideas for an underground home. We've not paid attention to the source of a worry across our partner's brow because we were worrying what someone had said about us on social media. It is, essentially, questionable whether we deserve to exist.

Ruskin is trying to wake us up. He has spent hours carefully tracing an entirely overlooked, wholly extraordinary feature of the world – and has turned it into a masterpiece of observation and devotion. He would, quietly, like us to do the same. He bids us to put aside our thrumming egos for a moment in order to look with care at a rock or the evening sky. He asks us to stop worrying about what others might think and how we might be viewed in four years' time. He tries to prise us from the prison of the self and free us to properly inhabit the world we claim to live in.

Émile-Antoine Bayard and Alphonse de Neuville,
illustration from Jules Verne's *From the Earth
to the Moon*, 1865

In 1865, two French illustrators and a science-fiction writer holed themselves up in an apartment in Paris and set to work imagining a journey to the Moon. They wondered what a rocket should look like and drew something with multiple stages that could be discarded on the way out of the atmosphere, leaving only a small shiny steel capsule to travel to the Moon itself. They wondered where a rocket might be launched from and, after a few calculations of escape velocities, decided on Florida. They asked themselves what the rocket should be called and came up with *Columbiad*. They speculated on how the rocket might return to Earth and had the idea that it might ditch somewhere in the middle of the Pacific. During a TV broadcast aboard Apollo 11, 104 years later, Neil Armstrong named Jules Verne as one of the reasons why he and his crew had made it to the Moon.

The power of art helps us to imagine the lives we want to lead ahead of our capacity to actually lead them. Verne and his illustrators had not, in their era, known exactly what propulsion mechanisms would be needed; they hadn't grasped much about the finer aspects of pressurised suits, lunar gravitation or radio telecommunications. But these were, in the greater scheme of things, details. What counted was that these artists had had the audacity to dream and to arrive at images that could guide subsequent, more incremental efforts.

It may not be the Moon we need to get to, but a picture of the future may be equally important in guiding us to our particular goals. We may need a picture of what it would be like to be married or divorced; how we could set up our own business; what it might be like to live in another country, take early retirement or assemble a new and better group of friends. We're so obsessed by failure and judgement that we quash most of our schemes long before they have even taken form. Our minds are too scared even to allow us to speculate on what we long for. 'What would you try to achieve if you knew you could not fail?' remains one of the most provocative questions we can put to our hesitant selves. Art can make us a map of a future we are as yet too timid to create concretely; it can set the path and wait for a few years – or a century – for us to catch up.

Slim Aarons,
*Sarah Marson Williams enjoys a cocktail on
the beach at the Hilton Hotel, Needhams Point,
Barbados, April 1976, 1976*

The photographer Slim Aarons fought his way across Europe in World War II and was awarded a Purple Heart for bravery. Afterwards, he explained that he had seen enough suffering and bombed-out villages for many lifetimes and that conflict had left him with only one certainty: that the only beach he ever wanted to land on in the future was one 'decorated with beautiful, seminude girls tanning in a tranquil sun'.

He dedicated himself to this task and, over a celebrated forty-year career, spent his time 'photographing attractive people doing attractive things in attractive places'. He shot them with a range of wide-angled lenses in Saint-Tropez and Saint Moritz, Mustique and The Hamptons, by the ice rink of the Palace Hotel and the pool at the Eden Rock.

It can be easy to worry about what might happen to us were we to look too long at certain images of beauty and charm; the concern has been there since the onset of art. The worry is that, after the castles and the feasts, the beaches or the ski resorts, we might not be able to cope with what we have in front of us; art will fatally weaken our capacity to endure reality.

But that is to misunderstand how much we may need to have periods when we fantasise – and art enables us to do so. The inventor of psychoanalysis, Sigmund Freud, made an instructive observation about babies and daydreams. When a baby wakes up terrified, wet and alone in the middle of the night, it can soothe itself by daydreaming that its mother is already there; it can cope with frustration through picturing that its desires have already been realised. In different circumstances, we might do the same with an image. Art can hold things together for us while we seek better options.

Rather than worrying about the risks of daydreams, we should be concerned about what may happen to people who can't have them. It is the inability to fantasise that may lead them to act out rather than dream their wishes. Fantasy is a critical safety valve. It is a frank admission of the goodness and appeal of so much that is still missing.

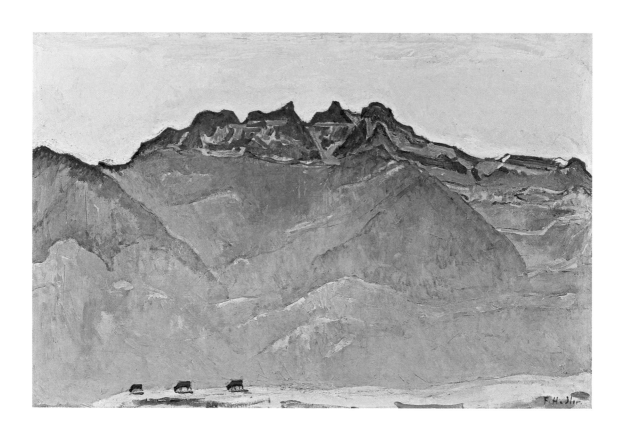

Ferdinand Hodler,
Dents du Midi from Champéry, 1916

The mountains weren't made to deliver a message to us. No one created them to articulate a philosophy. But that doesn't mean that they aren't well placed to do so, especially when framed through the talent of the Swiss artist Ferdinand Hodler, one of the greatest painters of any place and of any age.

We're looking up at the seven interconnected peaks of the Dents du Midi range that rise in an almost sheer vertical up to 3,000 metres from the fertile valley floor of Switzerland's Valais region, creating an astonishing, impassable wall of granite capped for six months of the year with layers of ice and snow, visited only by the occasional griffon vulture and marmot.

So much of our upset stems from being belittled by a world that refuses to accord us the respect and recognition we know should be our due. One way to appease our bruised sense of importance is to be made to feel small with definitive and magisterial force by something obviously mightier than any human. Our sense that we have been overlooked and treated badly by our fellow citizens can be subsumed by an impression of how petty and insignificant all our society's endeavours are next to the indomitable forces of nature, of which the peaks, created 60 million years ago by the titanic rippling of the earth's crust in the continental collision, are an especially impressive symbol.

In the shadow of the peaks, it matters ever so slightly less that our projects were rejected and our reputation sullied, that we have rowed with our partner and been misunderstood by so-called friends.

The real stars of Hodler's painting (among his last, as he died two years later) are not the mountains at all, but the three clever cows that he has carefully observed on the edge of a field. They care nothing for us and – with equal boldness – nothing for the spectacular scenery either. They are focused exclusively on finding their next mouthful of grass and enjoying the warming rays of the August sun. The follies that agitate us have no analogies in their hearts. They are not scholars or monks, but, through the good fortune of their biological make-up, they have already reached the state of benign indifference and serene acceptance of fate that the wisest of humans struggle to reach after a lifetime of devoted effort.

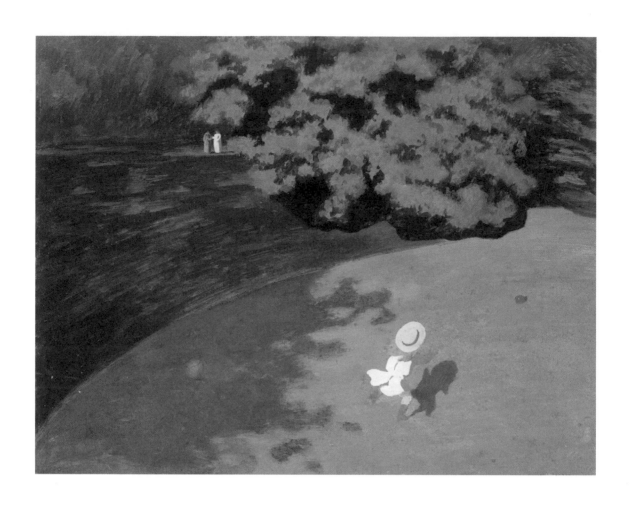

Félix Vallotton,
*The Ball (Corner of the Park with Child
Playing with a Ball)*, 1899

It is notoriously hard to capture a sense of movement in a medium as static as painting, but Vallotton has succeeded uncommonly well. He's carefully arranged our angle of vision and cleverly played with perspectives, bending the ground into a semicircle and roughing up the trees as though they were on a whirling carousel. We can feel the child's breathless energy. At that moment, the child won't have a second to think of anything sad or disturbing: their parents' disapproval, the tedium of school or a rivalry with a classmate. All that will count is their central objective, what they are straining to reach in order to give it another kick and continue the game: the bright red ball.

The painting begs the question: what might that ball be other than a ball? We might simply answer: the ball is whatever keeps us going, keeps us racing, keeps us excited and dwelling in an intent-filled moment. Seeing the child may trigger an impression of how much we miss such an objective. In most of our adulthoods, we cannot find our way to a pursuit that sufficiently motivates us, in which we can lose ourselves and thrill as we did during the games of childhood. We might look back on those days of play with nostalgia and a touch of envy – as the two women standing in the parkland watching the child might be doing (diverting themselves by worrying about whether they might get their clothes dirty in order not to have to grieve about a creativity they can no longer muster).

Play doesn't have high status; it lacks the power to generate money or respect. But if we are to have fulfilled adult lives, we should strive to think back to how we used to play as children, to recover contact with our native interests and aspirations. It was during those long days when we didn't think of an income or a reputation that we were in touch with what we truly loved – and so were close to major clues as to what we might do with our lives.

Vallotton extends us an invitation. Painting was his red ball. With charm and patience, he urges us to locate our own.

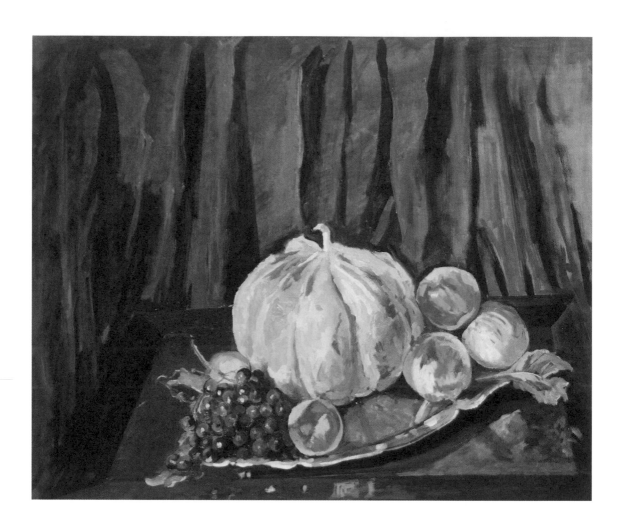

Winston Churchill,
Still Life, Fruit, c. 1930s

The most remarkable aspect about this very ordinary painting is who it is by. A man who over a long life held some of the most interesting jobs in the world – among them, Chancellor of the Exchequer, First Lord of the Admiralty, Home Secretary, President of the Board of Trade and twice Prime Minister of Great Britain – harboured an unusual wish: Winston Churchill longed to have been a painter.

Churchill painted whenever his schedule allowed, submitted his work to galleries in London and Paris under pseudonyms (Charles Morin and David Winter) and had a large studio built in his home. He knew he lacked the talent to turn his passion into his job; nevertheless, the things he most enjoyed about his painterly work reveal a great deal about what we might all long for in the jobs we have.

For a start, Churchill loved the speed of painting. Most of what he did in his day job took years, even decades, to come to fruition. But with painting, a satisfying result could emerge in a couple of hours; every day could feel meaningful. He loved how tangible the results were as well, being tightly gathered into a bounded stable space, unlike his professional work, in which the outcome of his contributions hovered in vaguer and more disputable forms. He loved how much of himself he could put into his work: there was no need for a dispassionate professional front; his full personality could make its way into his labours. Then there was autonomy, with no need to consult colleagues or authorities when taking major decisions about what brushes to use or how to arrange a line of trees. Finally, he could directly see how much pleasure his painterly work brought to others; the connection with the audience was immediate and visceral.

Churchill's case reminds us of how easy it is to be dissatisfied with even the most apparently prestigious jobs. The lesson is not that we should strive to become painters ourselves, but that we should pay close attention to the ingredients of professional fulfilment as these emerge from the art of painting and be on the lookout for them in the stewardship of our own careers. Most of all, and very cheeringly, Churchill's case reminds us that there is nothing unusual about feeling at odds with our work, whatever its acclaim or apparent prestige. It can be a sign of an admirable restlessness to be a little dissatisfied with what we are up to, and to keep searching and longing in new, unexpected and ever more authentic directions.

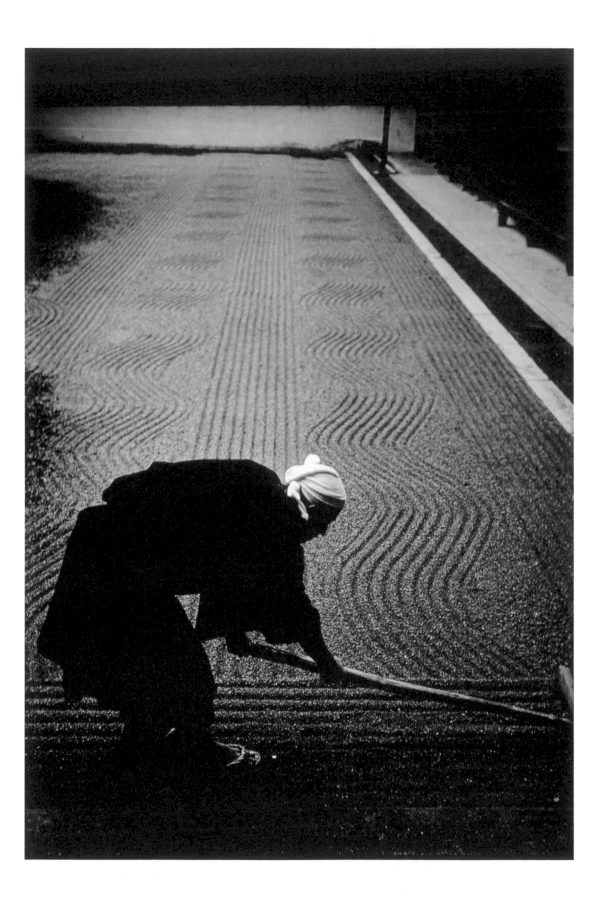

Burt Glinn,
Japan, Kyoto, 1961. A monk arranges
sand patterns in the rock garden of
Nanzenji Temple, 1961

The monks in the Zen Buddhist monasteries of Kyoto are up at dawn every morning with long rakes of bamboo with which to comb the gravel of their walled gardens into perfect geometric shapes: mostly long straight lines, but also waves, circles and eddies that flow around ancient, gnarled rocks.

It might seem the epitome of wasted work. Every day, leaves and debris will blow afresh into the gardens; every day, the gravel will get disturbed, and every morning, things will have to be rearranged through back-breaking toil. But the monks don't see this as futile – or rather, only appropriately and wisely so, as should be the case with all our work.

In their view, it would be folly to try to make the whole world perfect. The enlightened person knows to demarcate a specific area of the earth and declare that this, and only this, will be their zone of concern. Out in wider Kyoto or in the suburbs of Ibaraki, there might be litter and stray branches blowing across forecourts, but that is not their business. The garden is a metaphor for the boundaries we should all place around our concerns so that we can honour them properly.

There is wisdom too in a frank acknowledgement that, over time, our work will fade and its influence disappear. The monks are not trying to outwit the forces of nature; they know – for Zen Buddhism keeps making the point – that in the long run, all human effort is vanity. There is particular maturity in being able to accept our evanescent status and to make peace with the inherently temporary nature of everything good that we might direct our minds to.

A beautiful contribution – a perfect gravel garden, a well-arranged kitchen, a clean laundry cupboard or a tightly run business – is an achievement in itself. We shouldn't need them to last forever as well.

By raking a garden, we will have exhausted ourselves agreeably for a few hours, we will have brought huge pleasure to others and we will have kept our minds out of greater trouble. And that might be the best we can hope for from the noblest sorts of work available to humans in a fallen world.

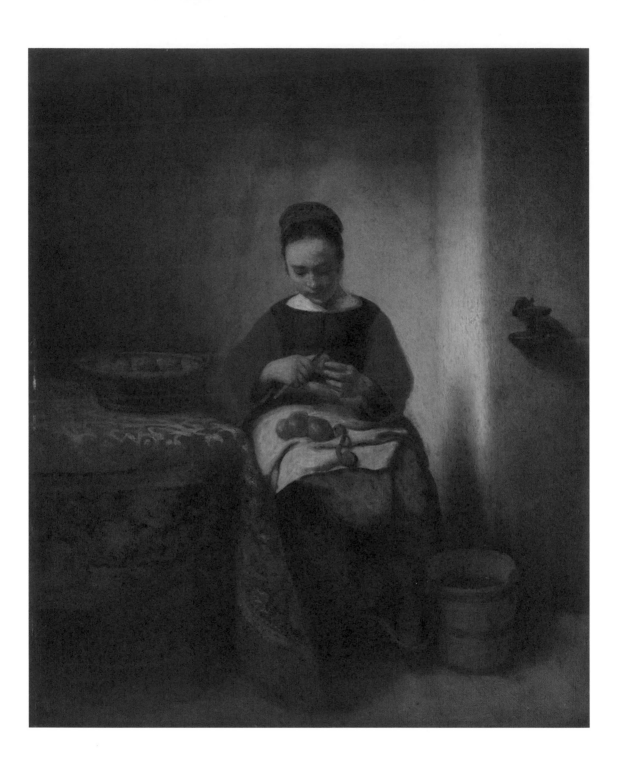

Nicolaes Maes,
Young Woman Peeling Apples, c. 1655

The economic injustices of the world have long appalled right-thinking people. It is self-evident that money does not fairly track effort and that virtue is seldom exactly or fairly rewarded. There are gifted, kind, hard-working individuals who earn nothing, and lazy, rapacious, mean ones who harvest fortunes. The most widely proposed solutions to this have been political and economic: redistributive taxation, wealth transfers, a more meritocratic education system … However, such measures can take a very long time to set in motion and the results are frequently uncertain.

Art holds out a more secure and more immediate solution: a transformation in the economy of respect. In this regard, the 17th-century Dutch painter Nicolaes Maes was a pioneer and a radical. Domestic work in his era – as in ours – held very low status. Poorly educated people doing so-called menial work earnt a pittance and were, to all intents, invisible.

In his own way, Maes has created a revolution with a brush. He has taken an apparently subordinate and unappreciated person and transformed her condition, psychologically as opposed to materially. He has increased by many times the degree of respect we can see she is owed. His portrait shows us the young person's dignity, her care, her modest nature, her kindness and her spiritually elevated nature; we are in no doubt that we're in the presence of a very special person.

In a perfect world, virtue would automatically elicit economic reward. Maes offers us the next best thing: a reappraisal of status. Money will for a long time yet remain unfairly distributed. Art cannot single-handedly change who is rich and poor. It can, however, alter how rich and poor are perceived. It can rescue from inattention and prejudice those who labour in the shadows but strongly deserve to be witnessed and esteemed. It can cast its redemptive glow on those who should be billionaires of money but can in the meantime be that next best thing: billionaires of respect and admiration.

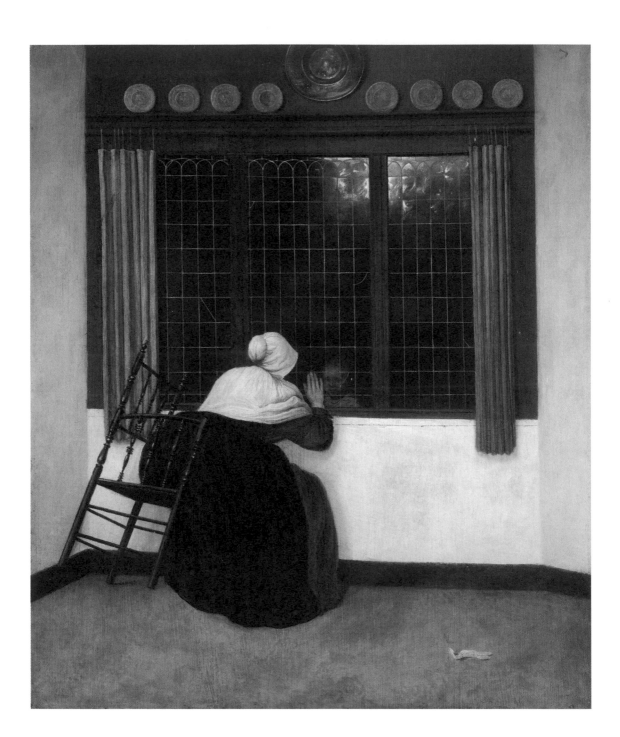

There's a story going on, a very lovely one, but we can't know the details for certain. In this respect, we are standing outside a window ourselves, in the most agreeable of ways. We can guess that the relationship is a kindly and tender one. This is Granny, Mummy, Nanny or Auntie, and just beyond the window, through those delicate panes of 17th-century Dutch glass, there is little Maries, Annelies, Sofie or Wilma. Maybe it's a game: *I'll run outside and wave to you and your job is to wave back.* Or: *You cover your eyes, I'll duck beneath the window, give a little tap and then you have to spot me before I drop down again.* Or, more simply: *When I have to go home after a day with you, I miss you so much and I like to say goodbye many times: four times in the room, twice from the hallway and once again at the window.*

In other words, in some undefined way, this is a portrait of love. An adult, probably quite a serious one who has known many cares and has considerable responsibilities, is bending to the sweet and imaginative will of a small person, in whose reflection she sees a version of herself (Vrel hints that the window is a mirror; the old woman is gazing at a version of her younger self). A grown-up who could easily have humiliated the child – said she was busy or that it was all too silly – is joining in enthusiastically and giving the ritual or game

her all (she might even fall off her chair).

One of the unexpected origins of something as serious and consequential as adult mental health arguably begins right here. If we find ourselves as grown-ups feeling creative, knowing how to appreciate ourselves, understanding how to remain calm and ready to give affection to others, it is almost certainly because at some point, a long way back, someone did for us what the woman in Vrel's painting is doing for the little girl: giving us attention, making us the focus of tenderness, appreciating us on our own modest but vital terms.

Children who end up sane have been spared the need to be very good or very reasonable too early. We can't know much about the economic status of Vrel's figures. What we do know is that such games and the love behind them belong to what it really means to have had that most invaluable of things: a privileged childhood.

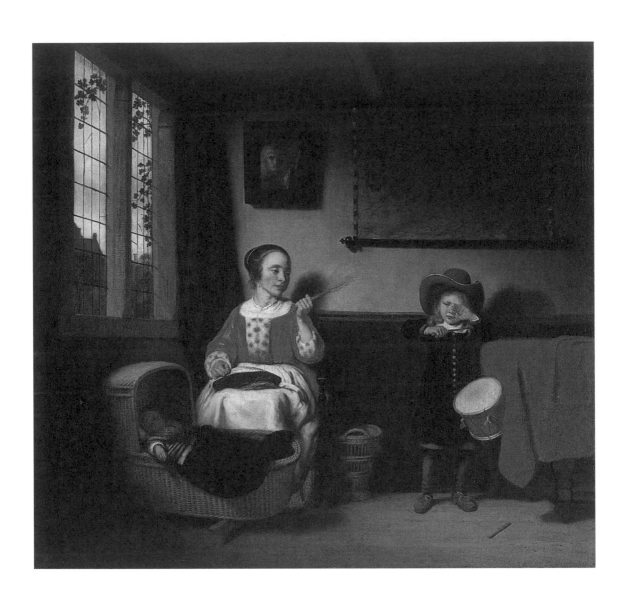

Nicolaes Maes,
The Naughty Drummer, 1655

Despite the title, he isn't naughty – he just loves drumming, and who can blame him? It's semimiraculous to be not even the size of a chair and still able, with a determined whack, to make a noise that can be heard all the way to the Oude Kerk. Uncle Pieter, who fought bravely against the Spanish and apparently single-handedly captured an admiral off Scheveningen, brought it around a few years ago. It was definitely a present, so why can't he do what he wants with it?

Even worse, this used to be allowed. Before the thing came along, that revolting spewing, oozing pink lump over whom every visitor now bends down and coos and whom they call Cornelia though its real name is 'it', everything was allowed: dancing, singing loudly, putting on a show at the kitchen table pretending to be Charles V. Everything got laughs and everything was beautiful. Mama was much nicer too; always patient, not saying 'careful of this' and 'don't do that' at every turn. She took him on her knee and stroked his hair and sang lullabies about mermaids and whales. It's the injustice of it all that, more than anything, makes the boy want to make even more loud music.

At the same time, it is easy to grasp from Cornelia's point of view. She didn't ask to be born and is finding it mightily confusing so far. There are so many sounds, lights, colours, moving things. Milk doesn't always come when it should; there can be an annoying shaft of light shining right into one's eyes – and then there's simply nothing to be done other than to let rip and wail.

In the midst of this is poor exhausted Mama, who wanted children so badly, who loves them so much, but who most days, despite her immaculate clothes and carefully arranged hair, is a mess inside, longing for more carefree days or even just an hour to herself to walk down to the Nieuwe Kerk and change her perspectives. The tension has given her the appearance of hardness. She holds her drummer boy's sticks with a lot of authority, but she wishes that goodwill and sweetness could always be enough. Yet if she wants to protect what she loves, she has to roar once in a while.

No one is bad, no one is naughty. Family life is just very, very hard.

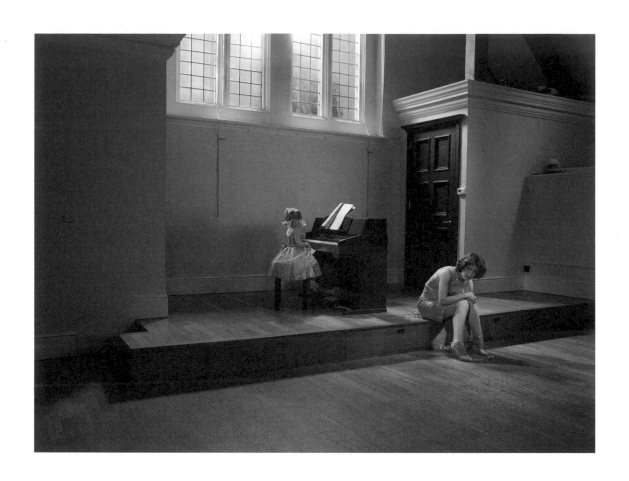

Julia Fullerton-Batten,
The Rehearsal, 2012

It should be an ordinary, even uplifting moment, but we can't help sensing that something subtly eerie and ambiguously uncomfortable is in train. The girl is a little too submissive and a little too disciplined for her own good: her dress is too endearing, her piano recital too perfect, the way she turns to ask us if we want to hear it again too laden with a hunger for an approval she shouldn't need.

At the same time, there is an alarming intensity to how much her mother wants all this for her (there may be ballroom dancing lessons and four hours a week of violin on top of this). Her own foiled ambitions have been redirected with too much force onto a child with claims to a different identity (football and trees, perhaps). Sometimes the mother doesn't seem very well; there are moments of distraction when she loses the thread and goes somewhere else entirely. It isn't easy for a 5-year-old to devote so much time to wondering whether or not Mummy is OK.

The image sheds light on an easily misconceived word. 'Trauma' tends to be associated with physical violence, war, forcible restraint or outright viciousness. But none of these need to be present for there to be substantial difficulties: trauma merely means an incident or a dynamic in a child's life that runs contrary to its interests but that it is too young and inexperienced to be able to make sense of or mount an effective protest against. Instead, it responds by turning the injury in on itself. It starts to assume that the fault must lie with its own nature; that it has done something wrong, that it isn't good enough. It hates itself as an alternative to getting angry.

It could be many years – three decades or more – before that little girl, now perhaps a highly acclaimed senior lawyer or civil servant with children of her own, falls into a depressed state she can't make sense of, finds her way to a gifted therapist and has a chance to go over the past with an adult mind. Despite what everyone told one another in the family, it wasn't a 'happy childhood' in any uncomplicated sense – and nor is she just a naturally driven high achiever. She can see now how much of a burden was placed on her – how unfair were the demands, how markedly yet inconspicuously ill her mother was and what role these factors played in the subsequent anorexia and divorce.

Parents rarely set out to injure their children, yet they are rarely well enough to be able to avoid doing so. Art is on hand to help us observe with far more subtlety and honesty than a sentimental family photo the quiet afternoons when, under a cover of ordinariness, the foundations of our subsequent troubles were laid.

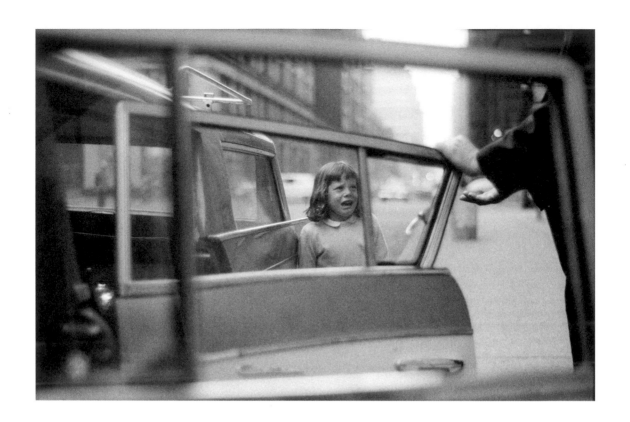

Joel Meyerowitz,
New York City, 1963, 1963

It was the summer of 1963 and Joel Meyerowitz was walking the streets of New York City with his Leica camera when, on the Upper East Side, somewhere around 76th and Madison, he came across a girl whose name we will never know, having one of the worst mornings of her young life. The wails resounded all around the brownstones. No, she wasn't getting in. No, she didn't care about what the time was. No, she wasn't going to listen. No, no, no.

Part of what makes young children's lives so difficult is that they have extremely powerful antipathies, worries, loves and dreads that make no immediate sense to grown-ups, because they lack the language or wherewithal to be able to explain them to adults. Their feelings are an outgrowth of the manic sensitivity, unconfined intelligence and wild imagination of the infantile mind. Small people are, in the best and most inspiring of ways, slightly mad.

Let's imagine that the girl doesn't want to get inside because she doesn't like the way the car looks. She hates the dark orange paintwork of its upper body; it reminds her of the colour of a house she once had to go into where another girl said something mean to her about her hair. Or maybe she doesn't want to get inside because the driver makes an odd noise when he swallows, or because there's a strange smell in the toilets at school, or be-cause she's been forbidden from taking her soft rabbit with her and she doesn't want Floppy to spend all day alone in the apartment staring at the wall and getting bored. But because all this is so hard to explain, most children simply end up screaming – then being labelled 'spoilt' or 'difficult'.

The child and the artist are in a sense in a similar predicament: both are uncommonly sensitive, both notice and are marked by 'small things' that are easy to overlook or denigrate (both might spend an age looking at a pave-ment, a flower or a snail). But artists are in a luckier position: they can bring to the sensitivi-ties of a child the powers of communication of a robust and ingenious adult. They can turn their tears into pictures and essays.

With their examples in mind, we should strive not so much to become less sensitive as to grow better able to convey what we are sensitive about – so that we will have a slightly better chance of being understood even by people who are in a hurry to get us into the car.

Natalie McComas,
*Five-year old Ryan's superhero party.
Eighteen children attended the party for
three hours. Total cost of party: $100*, from
Birthday Wishes, 2006

If a visiting Martian set their spacecraft down in a football field in a suburb of Brisbane and went to look over a garden fence at Ryan's fifth birthday party, they might conclude that the news about humans was both better and worse than they'd expected.

Worse because, as Natalie McComas records in her sympathetic yet unsparing photographic essay on Australian children's parties, the average child's imagination is alarmingly beholden to the worst of mass entertainment; there is no end to the plastic, the machine guns, the monsters and the princesses. It is worse because the intelligence of modern technological society has so overwhelmingly been directed at the production of cheap gadgets and valueless toys; because humans are destroying the planet through a senseless love of throwaway goods and mass-manufactured junk; because we are growing obese through our weak-willed addiction to trans-fats and glucose, cola and pepperoni.

Our condition is worse too because our well-meaning desire to be kind to children has often led to an increase in wilfulness and egoism; because we are unable to say 'no' not because we agree with a particular outrageous demand, but because we are too exhausted from our work and too weak from our divorces to stand up for what we know is right; because soon no one will be able to read a book or sit quietly for longer than four minutes; because the collective intelligence has been destroyed by our gadgets and because we keep buying gigantic vividly coloured trampolines on which our child emperors jump a few times before discarding them forever in a corner of our debris-strewn gardens.

But at the same time, the news is far better too, because despite everything, we continue to put enormous efforts into trying to bring up people who will know how to love and to be kind; because though we are ourselves no longer so young and now very far from slim, we throw the last of our energies into trying to educate and teach, into combing their hair and tidying their rooms, into hoping to bring some joy into lives we know will be every bit as hard as ours have been; because we continue to trust that it can be OK even while the evidence is, at one level, so bleak; because we are still so full of care and so committed to hope.

The Martians would be filled with wonder as they fired up their engines to head back out into the universe.

Raymond Depardon,
Glasgow, Scotland, 1980

Of course we feel for her. Her life isn't going to be easy. Her delicacy, her dreamy imagination and her sensitivity are so at odds with the grim backs of the tenement houses, in a run-down part of cold, wet Glasgow, which in 1980 was the poorest city in Western Europe. What will happen to her longings for what is gracious and cosy? What will the world do to her desire to sing happy songs, swing her legs avidly and look after her toy pony? She might have been much more content in a comfortable villa, close to a golf course or a library or, for that matter, in the upper chambers of a moated ancient palace. We long for her to grow up and escape and find the life she deserves elsewhere.

Here the mismatch between the individual and the environment is visually stark. But what we're looking at isn't so much a picture of one particular girl, at a specific moment, as of a portrait of a universal point of agony. The girl is the representative of the human soul (that is, of all our inner lives) when it is cast by unhappy accident into an unforgiving and unkind world. It happens in so many ways: a shy child is born to wildly ambitious parents; someone who loves carpentry and plumbing grows up in a family of rigorous intellectuals; a child who longs for simplicity and warmth is raised by servants in a frigid, opulent mansion. Like her, the home they are born into isn't their true home.

Perhaps because the idea of self-pity has such bluntly negative connotations, we often fail to have appropriate compassion for our own early circumstances. Like her, we were, almost inevitably, dropped to earth in the wrong place. We aren't to be blamed for feeling rootless and homeless. The things we do – the people we abandon, the traditions we reject, the loyalties we let slide – are easily cast as betrayals, but they are better seen as acts of fidelity: not to where we happen, accidentally, to have come from, but to who we really want and need to be.

"How do you spell 'hate'?"
1960s

William Steig,
"How do you spell 'hate'?", c. 1960s

William Steig put his finger on a central paradox of family life: that we spend a lot of time wanting to get away from and hating people we are dependent on and love. Importantly though, Steig did not turn this insight into a tragedy; he chose to tease us warmly for our ridiculousness instead.

Teasing done with affection and skill is a profound human accomplishment. All of us, in families especially, get a bit unbalanced in one way or another: too serious, too gloomy, too angry, too proud. We all benefit from being tugged back towards a healthier mean by a well-aimed, tenderly delivered tease. The good teaser notes our distinctive quirks and is compassionately constructive about trying to reconnect us with our better selves, not by delivering a stern lesson, but by helping us to notice our excesses and laughing at them. We sense the teaser trying – with love – to give us a slight shove in a good (and secretly welcome) direction.

The best teasing remarks emerge from genuine insights into who we are. A person has studied us, put their finger on a struggle that's going on in us and has taken the part of the highest – but currently under-supported – side of us. Teasing restores balance: it edges the intellectual to remember their taste for horseplay, the over-cautious to reconnect with their covert longings for adventure, and the over-earnest child to appreciate their own ridiculousness.

Teasing is a subtle, powerful mode of teaching. It builds on an important insight about human beings: criticism of any kind is exceptionally hard to absorb; we are very slow and reluctant learners with well-observed tendencies to ignore and turn against those who try to lecture us. By amusingly exaggerating our exaggerations, teasing combines criticism with charm; the negative point is real, but it is carefully wrapped in kindness and disguised as mere entertainment – and is therefore much easier to take on board. We are seduced into virtue. As the Irish writer George Bernard Shaw proposed, and Steig knew: 'If you want to tell people the truth, make them laugh, otherwise they'll kill you.'

Edward Gorey,
illustration from *The Doubtful Guest*, 1958

One of the greatest portrayals of love in American literature is to be found in a seventeen-page illustrated book, nominally for children but really for careworn parents, publishedin 1958 by Edward Gorey. *The Doubtful Guest* tells the story of a peculiar but endearing feathered creature, something of a combination of a mole-rat, a penguin and an anteater, dressed in a scarf and white tennis shoes, who one evening, quite mysteriously, shows up at the door of an aristocratic house peopled by a pleasant assortment of elegant, eccentric Edwardian-style characters. The family take in the creature, who has the wilfulness, oddity and charm of an independent-minded small child.

What's especially touching is that the family accept the creature on its own terms. They know it's not entirely normal, but that's OK by them; they like it anyway. Some days, the creature wants to put its nose to the wall and stay there very still for hours; 'and why not?' think the family. One time, it wants to hang out in the chimney; that's fine too. At points its behaviour does become trying, but the family always remain calm; at dinner, they continue to exchange conversation and have their soup while the creature eats a plate. Oh well, such things happen.

The Doubtful Guest challenges our ungenerous notions of love. We tend to think of love as what we give to someone who is exceptionally beautiful, clever, entertaining and perfect. Gorey suggests that love rightly understood is about extending imaginative sympathy and kindness towards what is difficult, gnarled, awkward and sometimes exhausting. The way a parent loves a child is in this sense the archetype of the way all adults should love one another; with immense sympathy for what makes us difficult, with faith that awkward periods can be overcome and with a solid understanding that what drives our worst episodes of meanness and difficulty are anxiety and fear, never 'evil'.

Gorey's art strives to adjust our angle of perception and warm our hearts. We may not have a long beak or like eating crockery, but we are odd and testing creatures nevertheless. The next time we are irritated and frustrated by someone, we should not dismiss them as idiots or monsters. We should take care to think that what we have on our hands is a strange but lovable feathered giant mole-rat in tennis shoes.

Alec Dawson,
Nobody Claps Anymore, 2014

This is a picture about how pictures may end up too compelling for our own good. The subject doesn't come up much in polite company; it is one of our most shame-filled moments. Soon the man will be up from his chair and pretending that none of this ever happened, though the same rigmarole will occur once again tomorrow night. We know that as many as thirty-five per cent of men struggle with the issue to a degree that they themselves find dispiriting; here, art is showing us more about ourselves than we care to know.

We should remain unflinching before the problem; it is neither ridiculous nor unfathomable. It starts with a simple design flaw. Brains that evolved to respond powerfully to stimuli that were once scarce never acquired a capacity for self-control commensurate with the temptations offered by today's techno-logically enhanced world. Levels of discipline that were at one point entirely adequate to deal with sexual opportunities in the small villages of the East African grasslands have been unable to cope with the sugar-coated offerings of modernity.

In all cases of addiction, it's never that we are simply greedy or lusty or depraved. We are addicted for a reason that is far more poignant and worthy of sympathy: because we are sad. The business of living is so desperately hard, relationships are so challenging, work is often so unfulfilling or boring, family dynamics so tricky and the capacity for honest kindly conversation so restricted, we may easily fall into despondency and confusion and spend hours in a row glued to the intense highs offered by images we know, in our sober moments, we abhor.

The cause of porn addiction isn't porn: it is careers that are fraught, relationships where we can't get our point across and projects that we can't manage. We should draw courage from the confessions of others, acknowledge the sadness in our lives and hold the pain and incompleteness in mind as we direct love at our broken species.

Hans Baldung,
Woodcut of Aristotle ridden by Phyllis, 1515

One of the most popular moral tales of the Middle Ages was a temptingly believable but in the end untrue story about antiquity's greatest intellect, the philosopher Aristotle. Though Aristotle was known for having led a productive life of reason, when he went to work as tutor to the young Alexander the Great, he was said to have befriended the exceptionally graceful Phyllis, Alexander the Great's father's mistress – and soon he could think of nothing and no one else. In order to avenge herself on him for his elevated ideas and self-righteousness, Phyllis gave herself to Aristotle only if he agreed to go around naked on his hands and knees while she rode him like a horse or mule, occasionally beating the philosopher with a leather whip.

Interest in this salacious story may seem petty and mean-minded, but it springs from a more poignant motive: a wish not to be alone with our problems. For most of us, sex is never far from a supreme complication: the existence of people supposedly above such frailties is a humiliation and a challenge. How could it be possible for someone to suffer no temptation to ruin their life in the name of sex? How could any human have entirely avoided the insanities of lust? We understand the temptation to venture forth the fanciful notion that Aristotle had not been so different after all. In his folly, he renders our own transgressions less squalid and rejoins humanity.

Therefore, the story is more than about an attempt to smear an eminent philosopher's name; it seeks to reassure us that no one is ever free of the madness of the body. We are ruined, perhaps, but others, far cleverer than we are, have been here before. The author of *De Generatione Animalium* and *De Sophisticis Elenchis* was on his knees long before we were, being slapped and whipped while watching his best hopes for himself disappear to the cries of his ruthless mistress' commands.

Lucian Freud,
Strawberries, 1952

Across the 20th century, many people came to believe that the task of art is to strip away our more pleasant ideas and turn our attention to the grimmer aspects of life. Our trouble, it was thought, is that we tend to be unduly cheerful and content, and we need art to shock us into recognition of sombre truths, particularly about ourselves.

One of the heroes of this approach was Lucian Freud, born in Berlin in 1922, the grandson of the founder of psychoanalysis and an early refugee from Nazi persecution. Lucian Freud was a notorious drinker and profligate. His most celebrated works are stark, oversized life portraits, often nudes, which relentlessly probe and expose the deep loneliness, anxiety and confusion of his sitters.

But this tiny work, only a few inches across, has a very different agenda. He peers into a small container of perfectly ripe heart-shaped strawberries, gently nestling on a grey-green bed of leaves; we can almost sense the delicate fragrance and the intense fresh sweetness of the fruit.

The work was never exhibited in his lifetime. Freud didn't even offer it for sale; it was an intimate gift to a friend, with whom he had lately been, as he was with almost everyone, demanding and difficult.

We can see this miniature still life as a shy self-portrait, and an indirect but moving attempt by the artist to convey that the worst sides of him – so often on show – were not the whole story.

Unlike the imagined audience of 20th-century art, we rarely suffer from too rosy a picture of ourselves or of others; we generally have no difficulty seeing our and their awfulness. The more urgent need is to rescue the smaller, sweeter, hidden-away elements of delicacy, tenderness, kindness and goodwill. We long for others to know and appreciate those parts of who we are, but they're easily bruised and we're hesitant about exhibiting them. Which is why, perhaps, it is so lovely when an artist – who is at least as bad as us – takes the first step and lifts the lid.

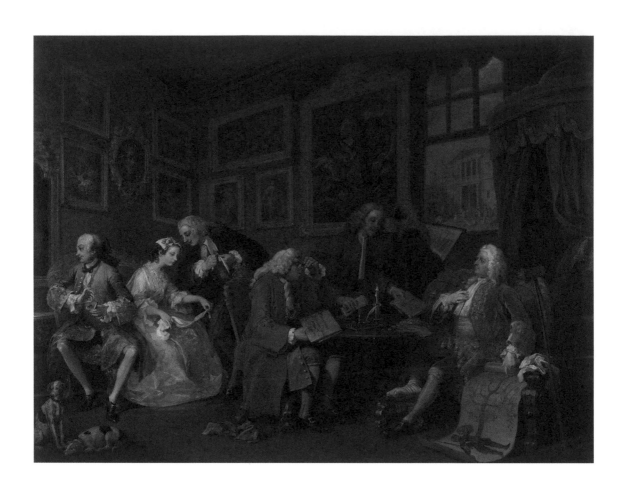

Hogarth asks a question that resonates down to our own times: what should a good marriage be based on? Thanks to his remorseless wit, we know what it should not be about. A wealthy merchant sitting in the middle is selling off his daughter (in white behind him) for a large sum to an effeminate viscount, the son of the bankrupt Earl Squanderfield, opposite him holding a family tree dating back to William the Conqueror. Cash is cynically buying up noble lineage, true love is being trampled on; in a corner, a chained bitch and a dog prefigure the young people's unhappy future.

Hogarth was a passionate defender of a remarkable idea: that we should marry people only because we love them deeply. We may now all agree with this Romantic attitude, but we also have to accept that it has proved to be a disaster of its own. We continue to suffer in marriage – and, as psychotherapy teaches us, we do so because we don't fall in love first and foremost with those who care for us in ideal ways, but with those who care for us in familiar ways.

Within our adult relationships, we seek to recreate the feelings we knew well in childhood – and that were rarely limited to just tenderness and care. We might only feel 'in love' when we are being belittled or ignored, patronised or betrayed. It's almost inevitable that we will marry someone who carries echoes of some of the faults of the parent whose gender we're drawn to.

Fortunately, this doesn't have to be a catastrophe. We simply have to direct our efforts to changing the way we characteristically deal with the dynamics we are attracted to. The way we tend to approach them is in the manner of the children we once were. For example, we over-personalise issues, we don't explain our distress, we panic, we retreat into silence. We go in for attention-seeking antics. Yet there is a properly grown-up – less agitated, less fragile – way of handling neuroses that would solve the problem of having married (as we all do) a fascinatingly complicated person. Hogarth identified the start of our difficulties, but his wit should not lead us to overlook a vital truth: that love is a skill to be learnt, never just an emotion to be felt.

David Hurn,
*Coach party from the valleys on holiday
during the fortnight close down of the pits,
Aberavon Beach, Wales, 1971*

To us there's a comic dimension: on the wide, inviting sands, they've corralled themselves within a rickety palisade of striped windbreakers, as our frightened Neolithic ancestors might have fortified themselves against their marauding enemies. They're looking placidly at each other, rather than excitedly scanning the misty horizon where the Bristol Channel edges towards the Atlantic. The world is on offer and they're resolutely ignoring it. We know we're supposed to feel shocked by and slightly contemptuous of their provincial insularity. Modern culture has taught us to identify with the solitary surfer in the distance (the first fibreglass boards had only just gone on sale in the UK at this time), who heads off in search of breakers and adventure.

And yet, we may feel a sneaking, ill-defined regard for the prim group on their deckchairs. They have something we so often don't: a deep sense of community. The doings of their little shared world are more important than what may be happening elsewhere. They're not seeking the new and the confronting because they've already found what they need: each other.

The heroic individualism of the modern age didn't properly factor in loneliness. Escaping the group – which had always suited a small minority of hardy souls – was advanced as the recipe for universal happiness, despite the fact that for tens of thousands of generations our ancestors had always lived in tiny, coherent bands, around people who shared the same tastes, with the same points of reference, where everyone knew everyone else. And suddenly we're not supposed to want or miss this.

The picture diagnoses an inadmissible illness: our yearning for home, a tribe of our own, the company of a like-minded happy few and an effective barrier, however seemingly light, to keep others out. It's not their palisade we want to enter, but ours. We might even start to feel sorry for the far-off surfer, who, like us, must face the chill waters alone.

Richard Learoyd,
Tatiana on Mirror, 2010

We are often taught that the best way to prove attractive is to smile. The idea feels logical and for the most part appropriate, but it overlooks the fact that a connection between people is often based not on celebration and grandstanding but on shared grief, sadness and melancholy.

This explains the surprisingly intense charm of attractive people who are resolutely not smiling, but instead look lost in thought, absorbed by their own sorrows and taken up with an internal dialogue around pain and loss. They may well pull a smile if asked, but it will be strained and brief. They are beautiful not despite their sadness, but because of it. They make the viewer feel in the presence of someone who would be in a position to understand their own brokenness, around whom it would not be necessary to put up a front in the name of seeming normal.

Our longing for love is powered by a desire to be understood and to understand. Given how much of life is tragic, it follows that for many of us, the sort of people we feel readiest to love are not those who find the business of living obvious or easy, but those who are as puzzled and saddened by it as we are; those who feel a regular need to withdraw from the sentimental bonhomie of daily life; those who are alive to anxiety and catastrophe – and who may, like us, frequently feel close to tears at so much that is regretful and sad.

We have been keen to pathologise and medicalise expressions of unhappiness, and our ideals of physical beauty have kept pace with our prejudices. Our billboards and movies loudly proclaim the virtues of glowing contentment. But we are in danger of missing out on one of the richest sources of beauty, which is when our faces drop their usual masks and visually acknowledge the pain of existence – a moment of honesty and vulnerability on the basis of which true sympathy can arise.

Little Tommy Tittlemouse,
owned by James Gowan (1907–1986),
manufactured in Germany, c. 1908

If we were ever tempted to despair about the human capacity for love, we might recover hope by considering James Gowan's relationship with Little Tommy Tittlemouse. The bear was given to him by a relative when he was 1 year old in Colonial India in 1908, and James was to talk to him and love him passionately and loyally until his death in 1986. Along the way, the bear went to boarding school at Stanmore Park and then Rugby, saw many foreign countries, received a postcard from James every year on his birthday (24th November), sat with him during a long marriage and got to know his grandchildren. Finally, at a distinguished age, after James had read an advert from the Victoria and Albert Museum calling for elderly bears to be gifted to a new collection of historic toys, he was handed over to his country for posterity.

One reason why our love for our bears tends to be so strong and so rewarding comes down to a paradoxical but telling detail: how little we expect of them. Unlike what we ask of humans, we don't need bears to understand us across all areas, to share every last taste, to express exactly the right opinions or to have identical views on how to throw a party, decorate a kitchen or spend the holidays. We just want them to be there for us, to listen quietly to us, to receive us in their arms and to look at us with kindness. On this slender and limited basis, true love has a chance to grow.

By contrast, we too often place an impossibly punitive burden of expectation on the human beings we love. We feel a partner must be right for us in every way, and grow intolerant and impatient at any departures from our hopes. We want them to approve of our taste in politics, to share our reservations about friends and to have just the right degree of suspicion of our parents or bosses. If they lapse in any area, we are liable to become furious, accuse them of betrayal and withhold our affections.

We are trying to do too much. By limiting what we expect a relationship to be about, we are often better able to honour the real claims of love. Guided by bear-love, we might realise that a bond between two people can be deep and important precisely because it is not required to play out across all practical details of existence. By simplifying and clarifying what a relationship is for, we release ourselves from overly complicated conflicts – and, as Tommy Tittlemouse understood, we can then focus on our urgent underlying needs to be sympathised with, seen and hugged tightly.

Garry Winogrand,
Los Angeles International Airport, 1964

At first glance, it looks like a picture of unalloyed happiness. Three sweet little children have come to the airport to meet what might be variously Mommy, Step-Mommy, Auntie or just 'a new friend', and Dad, to express his joy, has made a large welcome sign. But the more we look, the more peculiar and discomfiting the scene grows. Despite the size of the sign (or indeed because of it), the man emerges as strangely subordinate, passive, puppyishly over-eager and inferior next to Jane, in her colour-coordinated floral outfit and formal shoes. The man and woman might be pleased to see one another, but they are also standing a good two metres apart, without any wish or ability to move even a step forward.

The children look up at Jane with awe, curiosity and neediness. They have heard so much about her. They have picked up on Dad's anticipation and respect. But how much we worry for the five of them, half an hour from now, in the Ford Falcon, on the highway to-wards the San Gabriel Valley, with the children oddly silent in the back, the sign crushed in the boot and Dad's palms sweaty and tight on the wheel.

Perhaps they only ever met as pen pals? Even the reference to California now appears spooky; we know there is nowhere on earth where dreams curdle as fast.

If he had had the courage of his true anxieties, the man might have shown up at LAX with a very different message:

I want this so much to work, Jane, but I'm so scared it won't, as it didn't with Ashley and with Miranda before her. I'm worried I won't satisfy you in bed. I'm worried you will realise my weaknesses and find them intolerable. I'm worried you will hate the bungalow and will lock yourself away in the bathroom and long to fly back east. I'm worried about dying lonely and unfulfilled. Love me and forgive me, Jane.

The closer we get to most people's love lives – our own included – the more we should fairly want to weep.

Jan Steen,
The Sleeping Couple, c. 1658–1660

We reserve some of our deepest scorn for couples who stay together out of compromise; those who are making a show of unanimity, but who we know are not fully happy. Maybe they're primarily together because of the children, or because they're scared of being lonely, or because they don't have the money for independence.

These seem like disgraceful motives to be with anyone, because of a background belief that anyone who puts their mind to it doesn't have to compromise in love; there are always pain-free, profoundly fulfilling options available for all of us. Our high romantic expectations have made us notably impatient around, and censorious about, those who can't attain them.

But Jan Steen illuminates a different reality. His couple seems as if they drink too much and have fallen into a stupor. Neither of them is particularly young any more. They aren't a perfect match – and yet, through Steen's good-natured lens, nor does their union feel like a disaster. We imagine them rubbing along well enough, forgiving each other for their bad jokes, their farts and their stray nasal hairs.

What if our choices were, in many contexts, rather more limited than Romanticism proposes? Maybe there aren't as many admirable unattached people in our vicinity

as there might be. Maybe we lack the charm, the personality, the career, the confidence or the looks to attract the ones that do exist. Maybe time is running out. Or maybe our children would take it badly if we dynamited the family for the sake of better sex and greater cheer elsewhere.

A partner may be only half right, quite often maddening and properly disappointing in certain areas, but – humblingly – still more satisfying than being alone. The capacity to compromise is not always the weakness it is described as being. It can involve a mature, realistic admission that in certain situations there may be no ideal options.

Couples who compromise, like the one Steen portrays, may not be the enemies of love: they may be at the vanguard of understanding what lasting relationships truly demand.

George Thames,
William Masters and Virginia Johnson
interviewing a couple at the Reproductive
Biology Research Foundation, St Louis,
Missouri, 1969

We're at a pivotal moment in the history of sexuality. For a decade or so, two American researchers, William Masters and Virginia Johnson, have been investigating the nature of human desire and are now offering a therapeutic service to couples in difficulties in their Missouri offices.

Up to this point, there was almost nowhere to turn. Sexuality wasn't supposed to be discussed: it was hemmed in by taboos, myths and restricted notions about what might count as normal. But Masters and Johnson insisted that simply by having frank, non-judgemental and factually well-informed conversations informed by psychotherapy, a great deal of progress could be made. And they were right.

We might guess at what could have brought this respectably dressed couple into therapy. Maybe he's been having trouble maintaining an erection; perhaps she's been masturbating on her own; there are things they'd like to try but can't bring themselves to suggest to each other. The broader culture only alludes to such matters via demeaning myths and cruel interpretations: he can't be a real man; she's perverse and selfish; they can't love one another. There have been so many miserable nights, angry silences, wounded outbursts – and each has been carrying a corrosive, guilty sense that there is something terribly wrong with them.

Now, at last, the problems can be articulated to people who can help. Masters and Johnson can put things in perspective: what seems bizarre or disturbing to the isolated couple is revealed as very normal. They're not shocked or surprised by anything the couple might say: they've witnessed the same issues so many times already. They're gently understanding – even, at times, enthusiastic: human sexuality is fascinating, something to be curious about rather than ashamed of. There are exercises and structured conversations that can help.

What Masters and Johnson were offering may still be a novelty for us: we may still be living through our own, private version of unenlightened times when myth and fear predominate over understanding and skill. Yet the expertise and help we need exists – only an appointment and a burst of courage away.

Timothy Archibald,
Dan and Jan from *Sex Machines:*
Photographs and Interviews, 2005

Instead of just imagining possibilities in the isolated privacy of their minds, they've dared to ask one another frank and detailed questions: in a perfect world, if you could build any sort of sex machine, what would be the ideal angle for a thrusting movement? How deep should the penetration be?

In response, they've become practical. They've spent time over many weekends concocting a machine with various levers and controls to make the fine-tuned changes that will intensify and prolong their enjoyment; they've gone to great lengths to ensure the right kind of padding and a sufficiently robust frame so that their machine will survive the rigours of use. They've brought to sex the kind of inventiveness, resourcefulness and determination that might otherwise go into renovating the kitchen or putting up a garden shed.

Part of what's helpful about Archibald's work is that his heroes of erotic honesty don't look, in other respects, like great adventurers of the human spirit: he might drive a forklift truck during the day; she's a dental hygienist, perhaps. The setting is emphatically ordinary: the unremarkable sofa, the patterned rug, the pine cladding of the walls; their clothes are what anyone might wear. What's not on display, and we have to imagine, is the territory they had to cross with each other before this could happen: the first tentative hints and suggestions of their adventurous desires, over a takeaway pepperoni pizza at the kitchen table, or in the frozen foods aisle of the supermarket, not knowing how the other would respond, fearing being met with rejection and disgust.

They didn't get here because they are amazingly eloquent or highly sophisticated; they did so because they are not beset by shame, because they have been able to accept and tolerate themselves.

It's not that shame is inherently a stupid or useless encumbrance. It has a perfectly legitimate and important role: it holds us back from doing things that could be harmful to ourselves or to others. But too often our sense of shame is tragically amplified and misdirected: it latches onto things that carry no threat to anyone's well-being but are merely categorised as 'abnormal'. They may, in fact, be sources of joyful, shared excitement and, afterwards, of tender, loving hugs on the sofa.

Garry Winogrand,
Opening, "New York Painting and Sculpture,
1940–1970", Metropolitan Museum of Art,
New York, 1969

We may not have been to that exact party, and we may not know those exact people, but we recognise the deal well enough: the grandstanding, the careful glances around the room to locate the important ones, the anguished attempts to wriggle away from the clinging nonentities, the craving to meet those who matter. It's been the same for centuries.

The first question we are asked is: 'So what do you do?' And according to how we answer, we are either accorded smiles and fulsome attention or hurriedly left alone. We live in a world of snobs: people who ruthlessly judge us not by the quality of our souls but by external markers of status and power. The opposite of a snob is our mother; that is, someone who cares how we are, not how we are doing. But there aren't many mothers around at the Metropolitan Museum party, so the only thing that matters is what is on our business card. As the English writer George Orwell put it starkly: 'Once you're past twenty, no one cares whether you're nice or not.'

There is a curious poignancy to our craving to get on in society, for what we are really after is not so much money, preferment or jobs as respect and, if we can put it like this, love. We want people to notice us when we walk in a room; we want to be treated with consideration and sweetness. We are desperate to avoid humiliation. We aren't driven by greed so much as by a hunger for kindness.

It might be an art exhibition that has provided the excuse for this gathering, but – as Winogrand wryly signals – this party has nothing to do with the values of art: with truth or beauty, wisdom or authenticity. The good name of art has been used to justify a scrum. Yet, at heart, art would have the answers to what is going wrong here. Most artworks operate in the opposite direction to snobbery: they seek to help us pick up on the value of neglected things, ourselves included. They want to break down the barrier between so-called winners and losers. They want to show us that there is value in every square metre of pavement and in the heart of every human.

We should stop going to art parties and start giving parties informed by the values of art. At such events, no one would ask us what we did; they would care only about how we suffered and how they might help us to heal. We wouldn't feel such a hunger to be 'successful'; we would already have all the love that we needed.

Nuna peoples,
carved hawk's mask, southern Burkina Faso

It may hang in a museum now, but it was once a deeply practical object, as works of art are usually intended to be. In this part of Burkina Faso, the African hawk-eagle (*Aquila spilogaster*) is a master of all it surveys. It has its nest in the highest trees, can soar up to 3,000 metres above the savannah and can spot a mouse in the grass up to a kilometre away. The hawk-eagle can be recognised by its distinctive *kluu-kluu-kluu* cry and its streaked underwing feathers. If we could choose to be any kind of animal, the hawk-eagle might be a wise first choice.

The Nuna peoples who live in the African hawk-eagle's hunting grounds believe that humans can derive some of the strengths and powers of animals by carving masks that represent them and then dancing with them in a ritual way that summons up their spirits. Through dances with masks, a person can hope to make up for some of their own deficiencies, deriving the qualities of the right, compensatory kind of creature. A timid young person might be advised to dance with the carved mask of a crocodile on their head; an over-hasty and impetuous one would be steered towards the mask of a buffalo, whose placid nature and restrained strength they could hope to learn how to calm down with. Someone who was striving to become more ingenious at hunting or business (many Nunas

are small farmers) could be given the carved hawk's mask to whirl around the village with.

It might sound a fanciful scheme for emotional development, but it is not far from what we might be drawn to do with the works of art we encounter. We might, for example, want to pin a postcard to the wall of a red deer stag by the English artist Edwin Landseer to be inspired by its haughty air of indifferent grandeur, or of David Hockney's daffodils to bolster our reserves of modesty and patience. Or we might surround ourselves with books on Frida Kahlo in the hope that her independence of mind and defiance of social norms might guide us in our own quest for liberation.

We don't disrespect art when we use it in the hope of absorbing its strengths like this. We honour its power to help us through some of the trickiest passages in our lives.

Martine Franck,
*France, Hauts de Seine, "Maison de Nanterre",
old people's house*, 1978

She should, it seems, have little to be happy about. She only has a few months left to live, she had to sell the bungalow after the diagnosis, her knees are giving her trouble, she can't hear anything in her left ear, she's seen too many of her close friends die. And yet, extraordinarily, she is smiling.

Furthermore, though it sounds strange, she's happier now than she was a while ago, when she ostensibly had so much more to feel happy about, when she could run and hear a pin drop. She's certainly happier than she was at twenty, when she was deciding between Vincent and Albert; or when she was forty, and the kids were teenagers; or after the marriage fell apart and she moved to a small place outside Lille on her own.

All the worries have faded into the background. She is living, as certain Eastern sages have always recommended, entirely in the present. She doesn't look much beyond tomorrow. She is surprised and amazed to have made it until the spring. She studies everything with patience and wonder. *How extraordinary a rose is*, she thinks with the glee of a young child (one of the nurses brought it for her after her daughter mentioned the garden she had left behind). She had never been too interested in flowers until she was 60. Then they started to matter a lot. By that time, all her larger aspirations had taken a hit, and

she knew full well about the gap between her hopes and the available realities. So then flowers were no longer an insult to ambition, but a genuine pleasure amidst a litany of troubles, a small resting place for hope in a turbulent sea of disappointment.

She doesn't care about the so-called big things any more. When the politicians argue on television, she looks away. She has seen so many babies turn into old men, and brilliant young things fade into nothing. She doesn't worry about what will happen to the planet or get excited about what the scientists might discover. If you visit her, she just wants to know how you are and whether you might be cold or need something to drink. She's happy that you exist and that she can put her hand on yours.

In the end, all we will care about will be kindness. With the help of the right art, we should learn a little ahead of time.

Bernhard Lang,
Adria, 2014

It's fashionable to hate crowds. Bernhard Lang knows this. We are meant to crave being unique, and might be appalled to be only one identical parasol among thousands.

But if we examine our annoyance in detail, it's not actually the presence of lots of other people that bothers us. There are certain occasions when we have powerfully positive experiences of being one in a crowd – at the opening ceremony of the Olympics, or in a service in a cathedral, when the grandeur and solemnity of the occasion is profoundly enhanced by the fact that hundreds of people are acting in unison.

Keeping such experiences in mind shows us that it's rarely the quantity of other human beings that upsets us: it's the lack of a sense of nobility, ceremony or shared occasion. It's the bland ice creams, the smells of suntan oil, the badly dressed beachgoers. It could in theory be one of life's most majestic experiences to be gathered at the seashore in a moment of joint awe and humility at the sight of the shimmering waters before us. We don't hate people; we're missing the sense of dignified shared devotion. We don't really need every place to ourselves. We want there to be a crowd, only of a different kind.

On a densely populated planet, the ideal of being alone is understandable, but it has grown ever more problematic. All the interesting and attractive places get busy. The desire to journey away from the crowd leads us to a desperate scramble for ever more remote locations: the Galápagos Islands, the ice shelves of Alaska and (most exclusive of all) outer space; places that will, in turn, get spoilt too. The grander and more hopeful ambition is to transform our experience of being one of many; to turn the idea of a group from an insult to a virtue and to make belonging as nice as it can be.

Peter Paul Rubens,
The Three Graces, 1630–1635

According to classical mythology, the most beautiful women in the world were the Three Graces, the daughters of Zeus: Aglaia (radiance), Euphrosyne (joy) and Thalia (flowering). When the Flemish master Peter Paul Rubens sought to paint a gathering of these women, he was confident of what kind of figures he would need to accord them to depict them as the most alluring females of all time.

Rubens wasn't being insincere or coy or kind. In choosing what look to modern eyes to be overweight models, he was simply reflecting the common sense of his age. His picture was immediately popular because it showed what everyone at the time thought of as sexiness and beauty.

We assume our own notions of beautiful dimensions to be eternal when they are in fact relative and mobile. There are always more varieties of beauty at any one time than a particular society or era is willing to recognise: there is tiny-waisted beauty and flat-footed beauty, sad beauty and impish beauty, chinless beauty and jowly beauty. But seldom can we 'see' more than a fraction of these possibilities.

If every era tends to be blind, it is because we have such difficulty appreciating what is before us until it has been presented to us with sufficient skill, glamour and authority. One way to think of art is as a medium that has, throughout its history, used its prestige and technical talent to open the eyes of its audiences to kinds of appeal that would otherwise have been missed.

We can't shift the history of art and so of perception by ourselves, but we can notice – and draw comfort from knowing – that some of what we are right now may be being overlooked or condemned not because it should be, but because no artist or advocate has yet come along with the energy and skill to throw our virtues into relief. There is likely to be ample beauty in our features and in our souls, if only the wider world had the imagination to see it.

Sandro Botticelli,
The Mystical Nativity (detail), 1500

The central time for hugging is early childhood. Up to about the age of 5, most children are frequently held, cradled, patted and carried. We accept that a little person can't manage the trials of existence on their own. There will be times when they are overwhelmed and in need of a big person to take the strain. The young child can't be helped by explanations and reasons; they respond to touch alone.

It's tricky to admit how normal and reasonable regressive tendencies are. They can seem like an affront to individualism and dignity, but there can be no genuine maturity without an accommodation with the childhood self. To suggest that we continue to need hugs is to insist that we go on being, at points, rather like the children we once were; that is, people who can't cope alone. And that is fine.

It can be helpful to come across dignified and prestigious cultural objects that take the need for hugs seriously. In a late work, *The Mystical Nativity*, Sandro Botticelli (a great observer of the parent–child hug) shows a group of angels hugging adult humans.

Botticelli was sensitive to the way failure and fear are always edging their way into every life, irrespective of how sunny it might look from the outside. Few of us now believe that angels will help us out, but we retain the need for the sort of comfort they stand for nevertheless. The capacity to regress should belong within every good and loving relationship: it's a sign that someone feels safe enough with you (and you with them) to allow themselves to be seen in a pathetically vulnerable state. We've been too keen to exclude looking after another person when they are fragile or broken from our vision of relationships, but true love is as much about sympathy for vulnerabilities as it is about admiration for strengths.

Today it is pretty well understood that not getting enough sex may be a strangely intense problem, leading to stress, disconnection and difficulties with concentration. Not getting enough of the right sort of hugs should be recognised as no less serious. A hug is a symbol of everything we tend to sorely miss in our hyperindividualistic and achievement-centred culture: a chance safely to admit to our terror and total dependence on another person.

Henry Moore,
from *The Sheep Sketchbook*, 1972

In February of 1972, the 74-year-old sculptor Henry Moore moved into a new studio that overlooked a field of sheep. He had, he admitted, until then had no feelings at all about sheep; he'd hardly even looked at them, pejoratively referring to them as blobs of wool on sticks. But now, between breaks in the casting of his monumental sculptures, he took to looking out of the window and sketching the life outside: the ewes tending to the little ones, the solemn and stately expressions of the sheep, their bravery in the rain and their sense of play. Soon he'd filled an entire sketchbook that numbers among the most beautiful objects he ever made.

Moore realised that while sheep don't set out to teach us anything, we have a lot to learn from them nevertheless. One of their most consoling aspects is that their priorities have nothing to do with our own perilous and tortured agendas. They are redemptively unconcerned with everything we are and want. They implicitly mock our self-importance and absorption and so return us to a fairer, more modest sense of our role on the planet. Sheep don't know about our feelings of jealousy; they have no interest in our humiliation and bitterness around a colleague; they have never consulted a lawyer. When Moore came out to draw them, they ambled towards him, looked curiously for a moment, exchanged what ap-peared to be knowing, mildly amused glances with one another – and then carried on eating.

They walked around in circles or chased their little ones without any interest in which century it happened to be from a human point of view; they'd never heard of the economy; they didn't know what country they lived in; they didn't have any new ideas or regret what happened yesterday. They didn't care about the career hurdles or relationship status of the strange man who was revered by cultural types and sometimes fed them grass from his palms.

Time around animals invites us into a world in which most of what obsesses us has no significance – which corrects our characteristic over-investment in things that make only a limited contribution to the true and essential tasks of existence: to be kind, to appreciate, to forbear and to love.

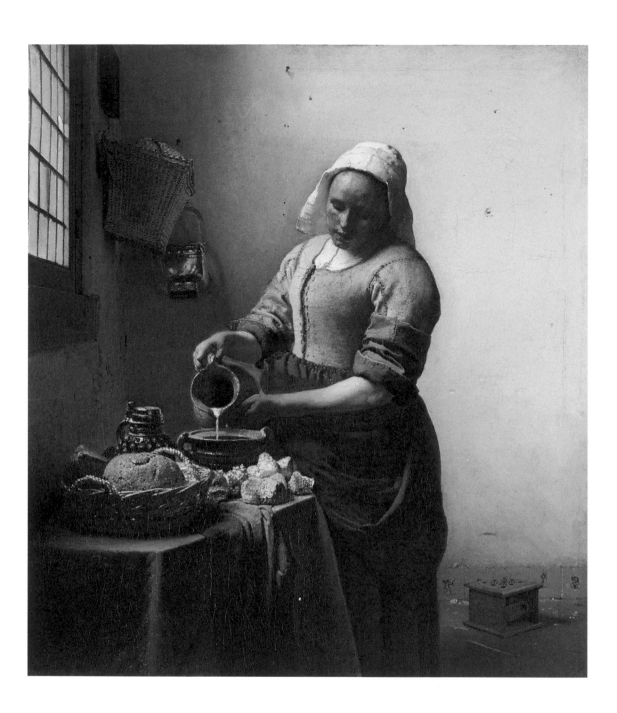

Johannes Vermeer,
The Milkmaid, c. 1660

Serving women – and bread and milk – were not regarded as especially exciting in the late 1650s, when Johannes Vermeer painted this picture, but he saw in the woman something that he felt deserved prolonged contemplation and admiration. By worldly standards, it's a pretty humble situation. The room is far from elegant, but the care with which she works is lovely. Vermeer is impressed by the idea that our true needs might be quite simple. Bread and milk are really rather satisfying. The light coming through the window is beautiful. A plain white wall can be delightful. Vermeer redistributes glamour by raising the prestige of the things he depicts.

A great insight of Christianity – which is ultimately detachable from the surrounding theology – is that everyone's inner life is important, even if on the outside they do not seem particularly distinguished. The thoughts and feelings of an apprentice tailor count for as much (from a spiritual point of view) as those of a general or an emperor. Vermeer paints his milkmaid with the same kind of consideration. She isn't famous or important in the eyes of the wider world. Yet, of course, in herself she is (like everyone) not in the least ordinary: she is uniquely, mysteriously and profoundly herself.

This picture has become one of the most famous works of art in the world. It is insured for half a billion euros (it's in the Rijksmuseum in Amsterdam) and is the subject of a mountain of learned articles. Yet the painting is curiously out of sync with its status. Above all else, it wants to show us that the ordinary can be very special. The picture says that doing normal things faithfully and without despair is life's real duty. It is an antiheroic picture: a weapon against false images of glamour. It refuses to accept that true glamour depends on amazing feats of courage or on the attainment of status. It argues that doing the modest things, which are expected of all of us, is enough. The picture asks you to be a little like it is: to take the attitudes it loves, and to apply them to your life. If the Netherlands had a founding document, it could be this small picture. It is a central contribution to the world's understanding of happiness.

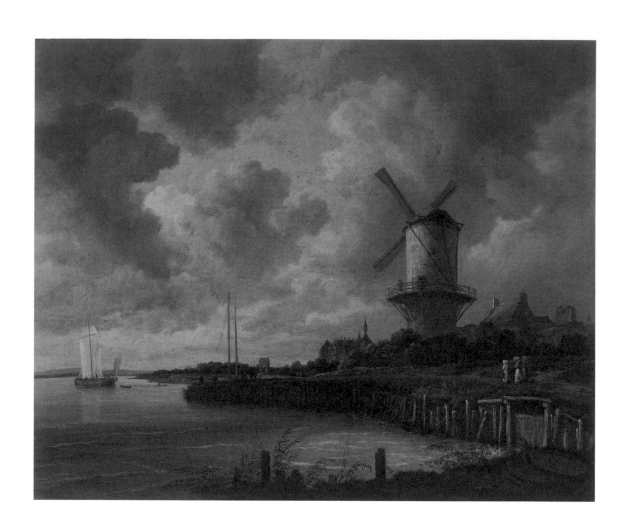

Jacob van Ruisdael,
The Windmill at Wijk bij Duurstede, c. 1670

The best kind of art and, by extension, philosophy of life, doesn't need things to be perfect. It searches out what is good amidst a grimness that it won't hide from us. Consider the point in relation to weather and landscape. We are committed to thinking that the only kind of day that merits the word 'nice' is one without clouds, rain, gusts or mud. We identify contentment with flawless skies and warm air and, by extension, a good life with an absence of reversals, breakdowns and scratches.

But, as one of Holland's best painters, the 17th-century artist Jacob van Ruisdael, understood, we don't need things to be ideal in order to locate beauty and interest in them. Van Ruisdael loved the Dutch countryside, spent as much time there as he could and was keen to let everyone know what he liked about it. But he also knew its reality: it's almost always overcast, there are many places where there's not a flower to be seen, it rains most days and there's always a lot of mud.

Instead of carefully selecting a special (and unrepresentative) spot and waiting for a moment of bright sunshine, he engaged unashamedly with the mixed, complicated reality. His paintings reveal a joyful accommodation with the flawed but endurable and occasionally beautiful nature of the world we actually have to live in. Van Ruisdael found his way to the merits of overcast days, learning to study the fascinating characteristic movements of stormy skies. He acquired a feeling for the infinite gradations of grey; he noted how often we can see a patch of fluffy white brightness drifting behind a darker, billowing mass of rain-dense clouds. He didn't deny that there was mud or that the river and canal banks were frequently messy. Instead he noticed a special kind of partial beauty and made a case for it.

We are all capable of making our peace with the less than perfect, and with life itself, if only our expectations are correctly calibrated; if we are inducted to recognise, and properly esteem, what is good within the thistles and thorns.

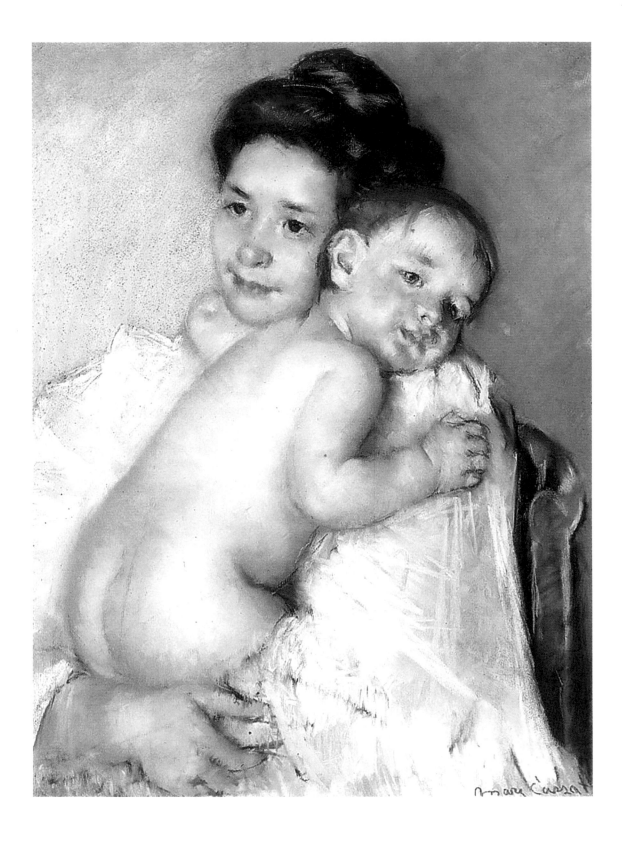

Mary Cassatt,
The Young Mother (Mother Berthe Holding Her Baby), 1900

Babies have much to teach us, as Mary Cassatt knew. Of course, we expect it to be the other way around: we teach them. But they are privy to a host of insights if we are ready to listen. They remind us that we are all dependent creatures. It's easy to play it tough now, to overdo our autonomy and independence. But we all began as tiny ones, recipients of continuous exhaustive ministration and attention. If we made it to here, it is only because we are heavily in someone's debt (and should probably call our mother).

The idea that we were all once babies is especially alien in the context of people we find weird or off-putting: the tramp, the maniac, the thief. But they all started off in exactly the same place as us. However different we may all be now, we share a common heritage. Therefore, there is always material from which a sense of identification and compassion can arise.

Others may be impressive and frightening now, but they were once tiny and fragile and retain some of that early vulnerability somewhere beneath their armour. It's a basic, levelling, democratic thought, like the idea that everyone, even the very important, serious and wealthy, have to visit a bathroom every few hours.

It's easy to be sickened by our species – the greed, the status consciousness, the vanity. We should hang out with babies as a corrective; they don't care if our car is big, they don't pay attention to what our job is or how much money we earn. They care about the fundamentals: cuddles, laughter, friendship, being with people who are nice to them whatever they look like. Deep down, we're perhaps all like this. It's society that corrupts us and encourages the wrong impulses. Babies are on the side of utopian politics. They argue that the world should be different from the way it is now. They're messengers of hope. Each one is an example of how we might all be, if only our societies could be differently and better arranged.

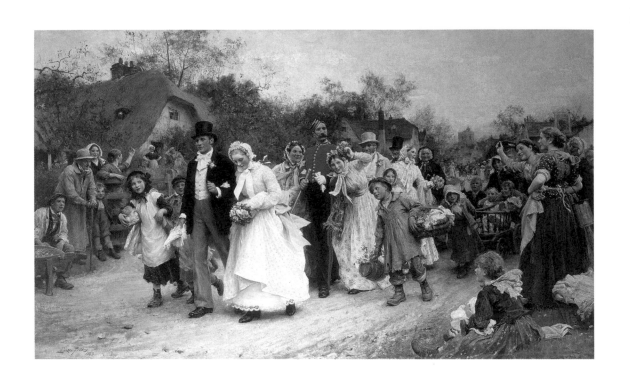

Samuel Luke Fildes,
The Village Wedding, 1883

Let's be blunt: this is a bad painting. Not on account of any technical flaw – Fildes was a talented draughtsman – but because of a failure at the level of psychological maturity; one that we can capture with the word 'sentimentality'.

Life is difficult for everyone: almost always a failure, and usually close to a catastrophe. We cannot escape our quota of bleakness and disaster. Not every grim eventuality will strike everyone – but, with dark reliability, many terrible things will happen to us all. In relation to this, our minds are prone to an unfortunate temptation: to deny the darkness, to try to shun news of the damned side of human nature, to flee awkward facts, to refuse to look inside ourselves at distress and to keep our attention always distracted, busy and manically fixed on whatever is pleasant and hopeful.

Oddly, we can observe this temptation with particular clarity in an incidental but revealing corner of activity: in sentimental art, a style that flourished in Europe and the United States from the mid-18th to the late 19th centuries, an art representing preternaturally glossy, airbrushed and unblemished scenes and people: young children at play, angels dancing, lovers embracing, cheerful peasants uncomplainingly ploughing and ever-loyal dogs resting at the feet of their benign masters.

Sentimental art is 'bad' because we intuit a psychological problem at play: we sense in Fildes' work a refusal to countenance anything that might be sad or dark about marriage. His work cultivates a highly edited version of ourselves as lovers. It shies away from all engagement with our shadow sides: our tendencies to infidelity, boredom, negativity and disappointment. He seems not to have chosen to look at the world cheerfully so much as to have been unable to face its sadness, locked into a grin; a victim of an insistent inability to square up with the nature of reality. He is, in the field of art, the equivalent of people who might ask us for our news, but be unable to listen to the answer if it contains anything irksome or distressing. The apparent good mood of *The Village Wedding* is not an achievement; it is the fruit of a rigidity driven by squeamishness.

As great artists and wise couples know, we can have good enough relationships without them needing to be perfect.

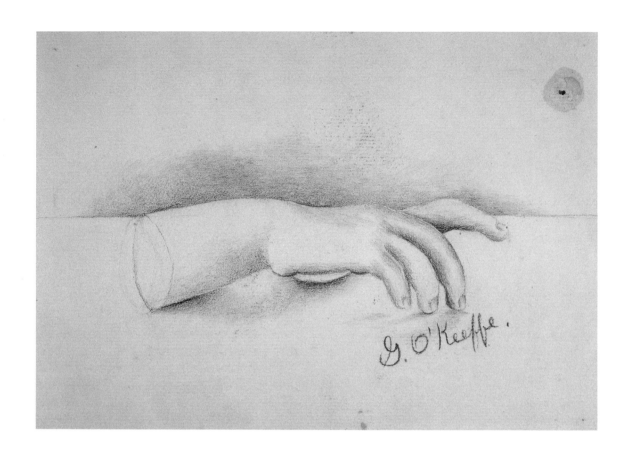

Georgia O'Keeffe,
Untitled (Hand), c. 1902

Georgia O'Keeffe was one of the most accomplished artists of the 20th century. She would also have been keen for you never to see this drawing – or almost anything else she did for a long time thereafter. It was sketched when she was 14 years old and just starting to learn how to be an artist at a boarding school near Madison, Wisconsin. Because the art teacher singled her out as mediocre and brought her to the verge of tears, she always kept the drawing to remember her beginnings. O'Keeffe would have another twenty years ahead of her until she became the artist she had always wanted to be and that we know her as.

The degree of effort and delay is instructive. We often imagine artists to have been born great rather than, in almost all cases, to have become great through unstinting effort. Through this forgetting, our own reversals come to seem far more definitive and telling than we should understand them to be.

Our perspective is imbalanced because we know our own struggles so well from the inside, and yet are exposed to apparently pain-free narratives of achievement on the outside. We cannot forgive ourselves the horrors of our early drafts – largely because we have not seen the early drafts of those we admire. We need a saner picture of how many difficulties lie behind everything we would wish to emulate. We should not look, for example, at the masterpieces of art in a museum. We should go to the catalogues of the juvenilia and there see the anguish, wrecked early versions and watermarks on the paper where the artist broke down and wept. We need to recognise the legitimate and necessary role of failure, allow ourselves to do things quite imperfectly for a very long time – as a price we cannot avoid paying for an opportunity one day, in many decades, to paint a beguiling set of tropical flowers that others will herald as masterpieces.

Philippe Halsman,
Marilyn Monroe reading in her apartment, 1952

One of the enduring prejudices of our age is that a person cannot possibly be both intelligent and beautiful, devoted to serious matters and alluring. That is why Marilyn Monroe presented such a conundrum, and suffered so much in her relations with men and the public at large.

She was, without doubt, a major intellect. On her bookshelf, she had titles by Erich Fromm, Albert Camus, Bernard Malamud and Thomas Mann; John Steinbeck and Walt Whitman were favourites; she subscribed to *Horizon*, then the foremost journal of high culture; she was studiously curious about the philosophies of Plato and Schopenhauer. In 1953, a year after the photo was taken, she was introduced to the acerbic and snobbish English poet Edith Sitwell, who admitted she expected to hate the actress, but found her 'deeply intelligent and sensitive'; the two became close friends.

Yet the myth that Monroe was 'dumb' has overpowered the reality. It belongs to a wider, puritanical ideology that enforces a stark choice: either we can be thinkers or we can be flirtatious and beloved. The cultures we often admire took the reverse view. In ancient Athens, the public was puzzled that Socrates could have been so intellectually prominent while being ugly and dishevelled. In the Renaissance, the great ambition of art was to unite ravishing beauty with lofty, penetrating intelligence.

Monroe tried hard to shift our mental block. Whenever she was asked to pose for a magazine, she always proposed that she should be pictured reading a book (there are over 100 images of her reading, rarely reprinted); sometimes she'd look dead serious, other times playful. But her overall point was always the same: she wanted people to think that reading could be sexy and that sexy people could be readers. She knew that important messages about wisdom and truth could go much further if they were wrapped in a charming exterior; that people who would have been far too frightened to pick up James Joyce's *Ulysses* might try it if she talked about it in public (as she often did). In a better world, she would have been made an ambassador for literature and an emissary for the virtues of the life of the mind. She would have been enormously gratified, and we would collectively have grown so much wiser.

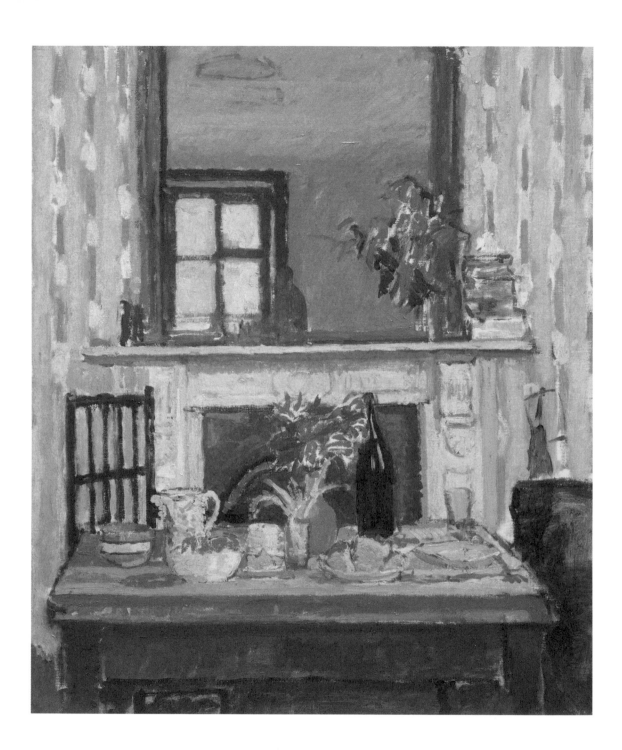

Spencer Gore,
Interior, 1910

We might be tempted to feel sorry for someone who confessed that their greatest pleasure in life was staying in, and looking around at, their home. What would need to have gone wrong for someone to prefer their own living room or kitchen to the theatres and clubs, parties and conference venues of the world?

But Spencer Gore saw nothing wrong with focusing his gaze on his home above all other subjects. A majority of the canvases that he painted before his early death at the age of 35 were of his two London residences, first in Camden, then in Richmond. His work suggests a deep acceptance of boundedness. He looks at domesticity with great generosity and newfound interest, and sees in what a home can offer one of the great triumphs and challenges of existence.

Gore encourages us to think that if a love of home is a consolation, then so be it. We might once have wanted to tame or educate the world, to have bent money to our will or to have gained the adulation of strangers. But such plans are inherently unstable and open to being destroyed by envy and vanity.

Gore shows us how a devotion to home shores up our moods when our wider surroundings grow hostile. We can find meaning in arranging flowers in a vase or preparing a simple nutritious meal. Gore was not running away from reality; his work remains political in the sense that it articulates a vision of what there is to value and defend. It covertly criticises ambitious generals and power-hungry politicians, business leaders and actors. It hints that waving flags at rallies and sounding important at meetings is all well and good, but that the true battles lie elsewhere, in the trials of ordinary existence.

With Gore as our guide, we might choose to stay in, do some reading, finish patching a hole in a cardigan, try a new place for the armchair and be intensely grateful that we have overcome the wish to live too much in the minds of strangers.

Allan Douglas Davidson,
She (The Blushing Girl), 1930

For anyone with a tendency to blush, the idea that there might be something positive about going uncontrollably red in front of others can sound absurd. But however uncomfortable it may be to blush, as Allan Douglas Davidson appreciated, doing so indicates a range of admirable character traits that we should honour in ourselves and welcome in others. Blushing is a sign of virtue. It's strong evidence that a person is, almost certainly, very nice.

We tend to blush from a fear that something about us might bother or prove unacceptable to other people. We blush after we've told a joke in company and worry that it might have come across as inappropriate or offensive. We blush when we abruptly realise that we may have arrived at someone's house half an hour too early for dinner (even if they are doing their kindly best to disguise the fact). We blush when we are concerned that something we said sounded boastful. We blush because we told a little untruth, feel ashamed and fear others see through us.

In other words, blushing is powered by an unusually strong ethical sense. It is generated by a terror of making others uncomfortable, a horror of inconveniencing people, a distaste for seeming arrogant or entitled and an overwhelming qualm about saying anything untrue.

These may be inconvenient feelings to experience, but they're very nice ones to harbour, because they almost guarantee that we won't turn into the unpleasant person we are so acutely sensitive to the dangers of being. Blushing is a guarantee of a fundamental honesty.

Someone with no capacity to blush is, for this reason, a scary possibility; they must implicitly operate with a dismaying attitude of entitlement. They can be so composed and sure only because they haven't taken on board the possibility of their unenchanting nature.

Excessive self-doubt can of course blight our lives. But blushing seems on the edge of something worth celebrating: an awareness that we might be a nuisance to others, which helps to make sure we never will be.

Govardhan,
A Discourse between Muslim Sages, c. 1630

During the high point of Mughal civilisation in India, a remarkable idea came to the fore: that spiritual and intellectual friendship could be thought of as infinitely more satisfying than love and should be the natural focus of all enlightened men and (as importantly) women. In the reign of Shah Jahan (1628–1658), the fifth Mughal emperor, prestige was directed towards the pleasures of conversation – usually outdoors, in the company of a few friends – about the most heartfelt and earnest things: humans' relationship to the divine; the purpose of art; the workings of the natural world.

We feel the appeal in the court painter Govardhan's rendition of such a scene; we might like to sit down beside the figures, fold up our knees as they do and have one of the most interesting conversations of our lives. In our times, the concept is unfamiliar. We invariably hear an invitation to a friendship as synonymous with consolation because our Romantic culture has continuously, and from a young age, made one thing clear to us: love is the purpose of existence; friendship is the paltry, depleted second prize.

But if we were to judge love by the way people behave under its aegis, we would have to judge it a form of exceptionally unpleasant insanity. Those we love we tend to honour with our worst moods, our most unfair accusations, our most wounding insults. In friendship, by contrast, we are patient, encouraging, curious, tolerant, funny and – most of all – kind. We expect a little less and therefore forgive an infinite amount more.

Paradoxically, as Govardhan's work implies, it is friendship that offers us the real route to the pleasures that Romanticism associates with love. This is where we will enjoy the wit, insight and kindness we crave; there might be flowers, too.

Culturally and collectively, we have made a momentous mistake that has left us both lonelier and more disappointed than we need to be. In a better world, our most serious goal would not be to locate one unique individual with whom to replace all other humans; it would be to put our intelligence and energy into nurturing a circle of true friends with whom we might regularly be able to sit on the grass, explore our minds and bare our souls.

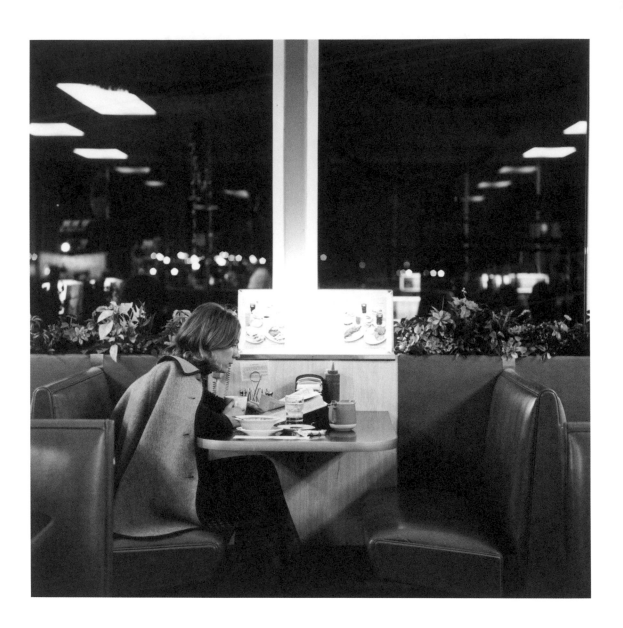

Too often, we equate the idea of being alone with shameful failure. We imagine that we can only be by ourselves because we have been rejected, because we have done something wrong, because no one wants to be with us. But in Robert Adams' photograph of a woman eating by herself in a Denver restaurant, a different vision emerges. We may be by ourselves not because we couldn't find anyone to be with, but because the available options would have left us feeling more lonely – more peculiar, less worthy – than our own company.

The waiter may have given her a quizzical look when she said that, no, she wasn't waiting for anyone, she was just going to have the soup and that was all. Some of the other diners may have speculated about what she was up to. But she doesn't mind. She looks strong, resolute and indifferent to what anyone else might be saying. She has learnt to forego the apprehensions of loneliness for the satisfactions of solitude.

She knows that her own company is, without vanity or exaggeration, more rewarding than anything presently on offer. It's not hatred of humanity that causes her to be alone, it's a willingness to wait until an equal arrives. She has realised that most people aren't going to be capable of conversing with her in the sensitive and informed way she cherishes; her dry wit leaves many people be-mused; her intense curiosity about the stranger but more revealing sides of human nature can be off-putting to some; the rapid but carefully structured sequence of her thoughts can prove too much. She's not especially proud that her mind works in a singular way; it just happens to be true.

Until then, she'd rather drape her coat over her shoulders and occupy herself with a true friend: a writerly type (who sadly died 150 years ago on another continent) who understands her like no one else in the vicinity and who is, this evening, once again, happy to have dinner with her.

Luis Velasco,
*Back of an Anonymous Scientist Working in a
Laboratory*, 2021

Minato has one of the most highly skilled jobs in the world. It would be useless to try to explain it in detail to a layperson; suffice to say that it has something to do with monitoring magnetic wave emissions during the encoding process of data units. At parties, they just say they're in computing and hope to shift the conversation. The job is prestigious and highly paid, and they had to work very hard to get it (a punishing first degree at Tohoku University, followed by a five-year PhD programme at Nagoya) – but there is one striking detail about it: often, especially in the afternoon, they get bored. There's a part of them that would love to spend more time kitesurfing; another part is drawn to the idea of owning a small inn on Shikoku Island. They're also obsessed by the music of Cole Porter and Duke Ellington.

The modern economy demands, and rewards, specialisation; we've known that since Adam Smith explained to us that wealth could only increase the more workers became experts rather than generalists. It is a tribute to the world Smith foresaw that we have ended up with such highly specialised job titles: Senior Packaging & Branding Designer, Intake and Triage Clinician, Research Centre Manager, Risk and Internal Audit Controller and Transport Policy Consultant. It's often hard to understand what anyone does any more. Smith would have been delighted.

However, deep in our hearts, we remain wide-ranging, endlessly curious generalists. As children, we would play at a dozen things in a single morning: being a pirate, a chef, a train conductor, a general, an astronaut and a nurse to our little sister. Each one of these 'games' might have been the beginning of a career. And yet we had to settle on only a single option, done repeatedly over a lifetime.

We are so much more than the world of work ever allows us to be. We have chosen to make work pay more rather than be more interesting. It's a trade-off and a sombre thought but a consoling one too. We are not alone in our frustrations. Everyone could have found so many versions of happiness. This worker, like all of us, contains multitudes; we are living only one of our many possible lives.

The man leaning against the aeroplane engine works for the ground operations division of Thai Airways; it's his job to insert and remove the wheel chocks when planes park in his zone at Bangkok's Suvarnabhumi Airport, as well as to open the cargo holds, oversee the loading and unloading of baggage and liaise with the jetty operator. Without him, the flight would never get off the ground.

His job is meaningful, but – as so often in the modern world – it doesn't quite feel so to him. An impression of meaning in jobs only emerges when we sense that we are, through our labours, making a difference. Most jobs do make one (they wouldn't pay otherwise), but because of the scale and pace of modern work, we are seldom able to experience our impact in any visceral or satisfying way. It's only too easy to believe, in an idle unobserved moment when resting against the rim of a Pratt & Whitney JT8D-1 engine, that we are wholly without purpose.

The customer and the worker are, in the gigantic structures of our world, kept too far apart. It can be hard to reassure ourselves of our worth when we are – to almost everyone we have helped – just a disembodied hand who shut a 737 cargo door after an interminable delay, or a figure in a high-vis jacket out on the tarmac in a tropical shower.

It's a tantalising paradox, and a quiet tragedy, that we may both pass our lives helping other people and yet, day to day, be burdened by a feeling of having made no difference whatsoever.

Fortunately, the photographer Chien-Chi Chang is on hand to help reconnect the disconnections of the world. Like all artists, he has the power to explain how an individual fits into the collective. His work lends this particular individual back his dignity. He has loved planes ever since he was a boy, and loves them still. Turning a flight around in under an hour is no mean feat. The airport is one of the most fascinating places in the world, and ground crew have a heroism of their own, every bit as worthy as those who get airborne. His job was always meaningful; it simply needs the thread of art to remind us that it is so.

Robert Adams,
Untitled (potato chips) from *What We Bought:
The New World, Scenes from the Denver
Metropolitan Area, 1970–1974*

As a species, we have waited a long time for this moment. We spent the better part of our history half-starved and terrified of going without. Now, in approximately the last two minutes on an evolutionary timescale, we have cracked it. We can have any variety of potato chips we like: flamin' hot, chilli lemon, original BBQ, sour cream and onion. They can be the size of pillows. We can take them home and dip them into salsa, guacamole, eggplant, chocolate sauce or ketchup. And yet still, somehow, we are not content. Indeed, if we stare at Robert Adams' photo for too long, we may want to start crying.

The subject is so melancholy because we can't help but sense – beneath our abundance – how much is missing, how richly we have satisfied our stomachs and yet how poorly we have fed our souls. What we really want aren't aisles filled with discounted lamb cutlets and tacos, burgers and peri-peri-flavoured chicken wings; we are looking for tenderness and love, understanding and sympathy.

When we eat too much, the problem is never that we are hungry, it's that we are lonely and grief-stricken. When reaching for the third bag of potato chips of the evening, the problem isn't our unconstrained appetite; it is the difficulty we have in accessing the emotional and psychological nutrients that would feed our broken hearts – nutrients that include understanding, forgiveness, reconciliation and closeness. We eat too much not because we are (as we brutally accuse ourselves of being) greedy, but because we live in a world where the emotional ingredients we crave are in such short supply.

A vast quantity of human ingenuity has been devoted to enticing the palate. We have succeeded beyond our wildest expectations. But in the emotional arena, we have hardly begun to supply ourselves with what we long to consume. Our shelves remain bare. If we could have ready access to sympathetic friendliness, warmer and calmer relationships with those we love, clearer knowledge of our true ambitions and better self-knowledge around our own failings, our waistlines would be under a lot less pressure. We continue to eat, not because we are hungry, but because we cannot find anything more satisfying to absorb.

Abbas,
*India, 5, Rajasthan, near Bundi, section of
a highway being constructed, 2016*

We're in a taxi in a suburb of Rajasthan. Soon there'll be a highway here. Recently a container port opened. New money is streaming in. There are opportunities for drivers like the one portrayed here. Why then does this look like another vision of hell, one of a particularly modern, frenetic, technologically inspired kind?

Those who would like us to think well of the world and its future always point to our industrial and scientific prowess. We're urged to be glad to be living in our own times, and even more excited to be around at any point in the future, when our gadgetry will have grown yet more refined. We would be churlish to scoff at human ingenuity; that highway is undoubtedly impressive.

Yet every invention for which humans have been responsible carries with it both a benefit and a drawback. According to the law of simultaneous regress, every advance has to be paid for by some form of appalling proportional regress. It's been a long time since there was calm in the streets of Rajasthan.

Our inventions ostensibly give us more power. But unfortunately, increased power is only as beneficial as an increased capacity to deploy it well. Otherwise, it is merely a tool for misuse and chaos, akin to giving a toddler a handgun and then, with a lot of hullabaloo, following it up with a machine gun. We have not managed to increase our capacity for wisdom. We are every bit as brutish as our ancestors, but are a lot better armed, fed and with a lot more time on our hands to generate mischief. We can communicate ever faster, but have nothing more interesting to say. We can access infinitely more information, but have no better grasp of what we are searching for. We drive faster and further, but without any valid sense of our ultimate destinations.

We would do well not to cheer too much the next time a breakthrough is announced in tech or commerce. Until we learn to develop the quality of our thoughts, we should not expect any number of highways to do us any straightforward good.

Lucas Cranach the Elder,
The Fountain of Youth, 1546

On the left-hand side of the painting, the old arrive from across the land by mule and by horse, by cart and by wheelbarrow; one character staggers in on someone's back. By the water's edge, exhausted, they strip off their rags and heavy cloaks and, under the gaze of a doctor, clamber gingerly into the pool. Their skin is grey and sallow, their limbs heavy and pockmarked – but within a few steps, the magical properties of the Fountain of Youth start to work their effects. Suppleness returns, stomachs become firm again, cheeks fill out, necks return to their original tautness. By the time they reach the other end of the pool, the bathers have become nubile and athletic, they giggle and saunter, they can run without pain, their hair is luxuriant and their eyes bright; all the intervening decades have been wiped away and they are starting their adult lives once more.

By the time Lucas Cranach finished his depiction in 1546, the idea of a Fountain of Youth had been a well-established trope of European art for two centuries. Ostensibly, the legend captures our longing to recover physical grace, but the substantial fantasy is to be able to go back and expunge our regrets: there is so much that we failed to notice and to do, so many opportunities we squandered, so many mistakes we could have avoided.

Depictions of Fountains of Youth are a version of the fantasies we might ourselves entertain in the early hours when we picture ourselves back at university, aged 18, knowing what we know now. These Fountains aren't merely cruel or childish; they represent an acknowledgement of just how badly most of us spoil our prospects. They testify to the firmly rooted yet impossible wish to correct our error-strewn past. We can never bathe in Cranach's healing waters, but we can take a little solace in the knowledge that our grief is not ours alone, that all of us are obsessed with the wish to go back and warn our younger selves of the dangers, that all of us are victims of an inherently excruciating existence that forces us to move forward blindly and then only ever understand – and weep – retrospectively.

Rembrandt van Rijn,
The Woman Taken in Adultery, 1644

It's one of the most famous and harrowing moments in the New Testament, chapter eight of the Gospel of Saint John. Jesus has recently come down from Galilee to Jerusalem when some Pharisees, members of a sect focused on precise adherence to Jewish tradition and law, present him with a married woman whom they have caught having sex with someone other than her husband. 'Teacher,' they ask him, 'this woman was caught in the very act of committing adultery. In our law, Moses commanded that such a woman must be stoned to death. Now what do you say?'

Jesus is being edged into a trap. Will he say that it is fine to have an affair (in other words, to condone something that our society regards as sexually very wrong)? Or will the mild-mannered preacher of love and forgiveness turn out to be just as strict about legal matters as the Jewish authorities he liked to criticise?

Jesus makes a deft move. He doesn't categorically deny the mob the right to stone the woman to death, but he adds one apparently small but in practice epochal caveat to this right. They can kill and destroy her to their hearts' content if – and only if – they can first satisfy one crucial criterion: *they have never done anything wrong themselves*.

Only absolute moral purity grants us the right to be vicious, high-handed and unsparing towards transgressors. Jesus responds to the Pharisees with what have become immortal words: 'Let him who is without sin cast the first stone …' The mob, understanding the rebuke, put down their projectiles and the terrified woman is spared.

The real target of this story is a perennial problem in the human soul: self-righteousness. Jesus argues that the surest way to be kind is not to take pride in never having done a particular species of wrong. It lies in seeing that, inevitably, we too have been foolish and cruel at other moments, and in using that knowledge to foster compassion towards those whom it lies in our powers to 'stone'. A world in which we keep our own wrongs firmly in mind becomes, paradoxically, a properly virtuous and humane place.

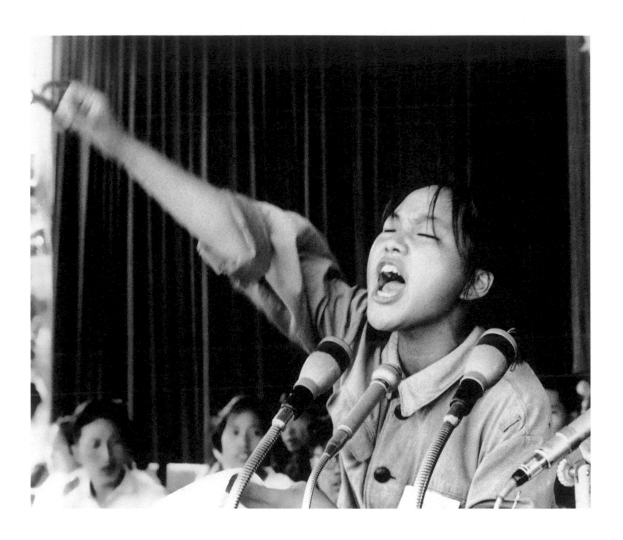

Associated Press,
*A 15-year-old girl emboldens her fellow Red
Guards during the Cultural Revolution*, 1966

She is calling for the death of all bourgeois traitors; she wants every last intellectual punished; she is screaming her loyalty to Chairman Mao. She would have you killed. She is 15 years old.

For ten long years, starting in May 1966, China lost its mind. Convinced that his revolution had fallen prey to reactionary forces, Mao Zedong urged his country's young people to turn against their parents, authority figures, artists and scientists. Ten million people, including some of China's greatest intellectuals, died in the chaos of the ensuing Cultural Revolution. Bands of self-righteous students pulled their elders out of their offices and forced them to make public apologies for 'bourgeois sins'.

'Sorry' never seemed to be enough. No sooner had someone confessed than he or she would be imprisoned or shot. Things that people had written ten or twenty years before were dug out and used against them; private diaries and correspondence were leaked to destroy reputations. People who had once sought distinction in their careers attempted to disappear. Colleagues who had worked together for decades tipped off the authorities in the hope of shoring up their positions. For those for whom it was all too much, suicide beckoned.

It may all have happened in a particular place and time, but the essential story is universal. It has happened many times before, and will occur many times again in the future, under different guises, with slightly different causes, perceived enemies and notions of virtue at play. It won't always be called the Cultural Revolution, but it will always be the same event deep down: a spectacle of denunciation, self-righteousness, cruelty, vengeance and mob rule. It might happen in public squares or, more insidiously, closer to home, in offices and online forums.

Wherever we are living, however apparently peaceful, democratic and law-abiding the official climate, we should never forget this archetypal story. It belongs to a dark knowledge that should protect us from hope, from misplaced trust and from a relaxation of vigilance. The culture we live in is violent, tribal, unforgiving and sanctimonious. That is why goodness isn't merely 'nice', it is life-saving. Tolerance, patience, apology and modesty are the pillars of civilisation – and the true subjects of art.

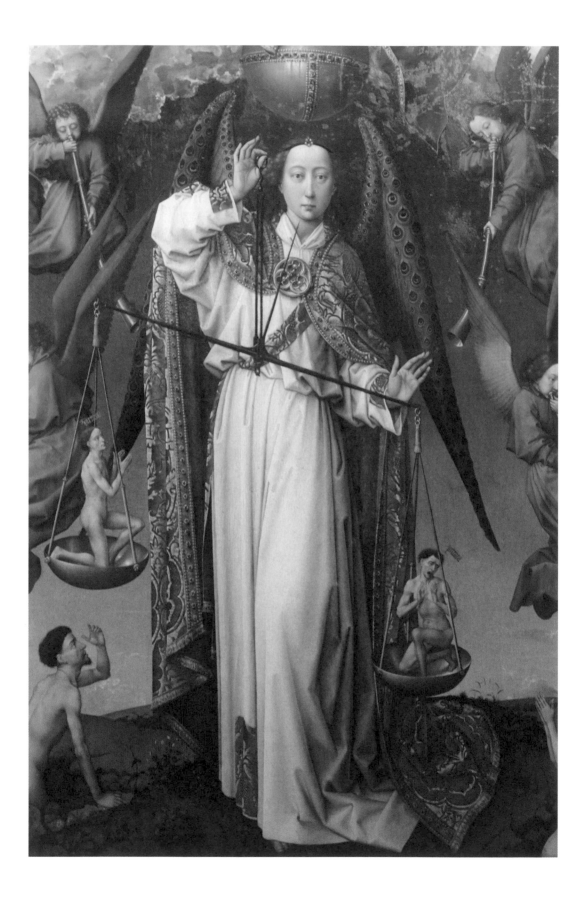

Rogier van der Weyden,
Archangel Michael weighing souls from *The
Beaune Altarpiece* (detail), 1445–1450

It's the end of time and the Day of Judgement has come. God and his angels are weighing up the souls of every human, sending some to heaven and others to hell. It's one of the strangest notions ever devised, but it enforces some sensible principles of how to live wisely and kindly among others. It operates as a reminder of the dangers of judging one another too readily and confidently, of quickly deciding who is valuable and who can be ignored, of too narrowly settling the question of who is guilty and who is innocent.

The theory of the Day of Judgement proposes that the merits and demerits of other people are fundamentally mysterious, that important factors about their situation will never be known to us, and that we are therefore likely to get things wrong if we rush to assess others' value on the basis of outward markers. It commends us to pause our judgemental proclivities and snobbery and to adopt instead an attitude of modest and kindly neutrality. The Day of Judgement is useful not so much as a prediction about an event that will unfold on the other side of the grave; it matters as a warning to us not to foreclose on people whose true natures and situations we cannot understand as we truly or fairly should.

The Day of Judgement is a strategic counter to the excesses of a meritocratic world-view. Faith in a meritocracy insinuates that we can, without excessive difficulty, judge others right now, almost at a glance, on the basis of what they have achieved, and condemn the losers and try to befriend the winners. But to judge so quickly on the outward signs is almost certainly to miss some key things about others; they in turn may make the same painful mistake with us. Via magnificent works of art, religious ages knew to remind us to leave the judging to far cleverer and more beautifully attired angels.

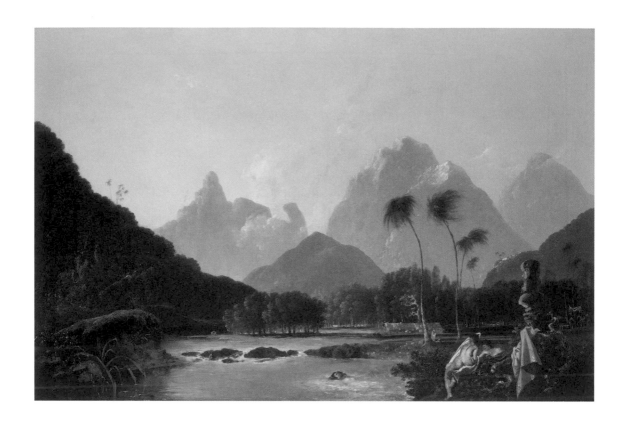

William Hodges,
Tahiti Revisited, 1776

When the explorer and navigator James Cook arrived in Tahiti on his ship the HMS *Resolution* in August 1773, he and his crew found themselves in one of the most enchanting lands they had ever visited. Fortunately for us, there was a talented painter on board, William Hodges, who captured the scene for posterity. When Hodges exhibited his paintings in London in 1776, they created a sensation: here, at last, was the land of beauty, ease, sexual freedom and plenty that writers and artists had been anticipating since the Ancient Greeks. Except that rather than being a fantasy or a religious promise for the next life, it appeared – through Hodges' canvases – as if the place were real, lying concretely in the tropical regions of the Southern Ocean, bathed in warm air and rich sea currents.

It is easy to fantasise that, if only we could be in such a landscape, we would at last be content. Viewed from the cold, windswept regions of modern civilisation, anything else feels simply implausible. But we should never confuse enthusiasm in front of a work of art with a travel plan. To journey to Tahiti would mean – tragically – having to take ourselves with us, a maddening encumbrance that art subtly and kindly allows us to push aside for a few moments as we loll in daydreams.

If, with luck, we scrabbled together the necessary funds and disembarked, dazed and bedraggled, in warm humid air after a twenty-seven-hour trip, we would learn, despite a coconut and mango welcome drink at our hotel, that very little of what had sickened our soul in our old life was capable of being dispelled by the landscape and the climate.

Contentment is an elusive and whimsical partner that seldom agrees to accompany us obediently on our journeys. We shouldn't compound our anxieties by imagining that we would ever be able to escape them. We should be grateful to art for giving us a picture of what it would be like to reach ease and joy, but we should be careful never to assume that securing these would require anything less than a lifetime of – psychological rather than touristic – effort.

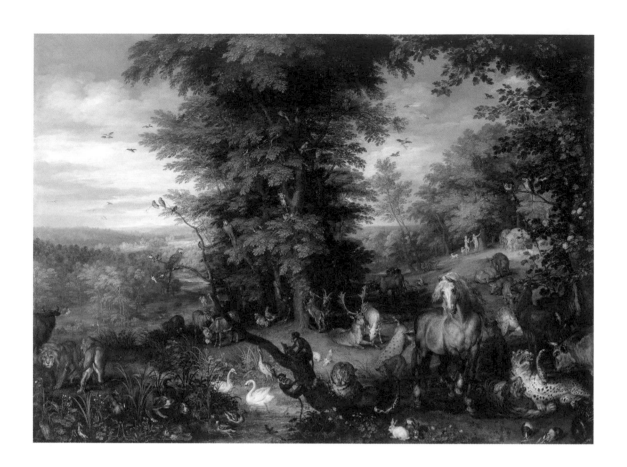

Jan Brueghel the Elder,
Adam and Eve in the Garden of Eden, 1615

It looks like the ideal place: there would have been tasty things to eat, beautiful vistas, friendly animals, constant good weather. But as the artists who kept showing us paradise for many centuries knew, there were solidly founded reasons why we could never return to such a place and so why life was fundamentally rather difficult.

The reasons had been laid down in the late 4th century CE, as the immense Roman Empire was collapsing, by St Augustine, the leading philosopher of the age. Augustine was interested in possible explanations for the tragic disorder of the world: why were people so wicked, why were we so unable to be kind, why did we find it so hard to love?

In response to such questions, he developed an important and influential idea that he termed the theory of *Peccatum Originale* (original sin). Augustine proposed human nature to be inherently damaged and tainted because, in the Garden of Eden, Eve (just visible in the top right-hand corner), the mother of all people, had sinned against God by eating an apple from the Tree of Knowledge, and handed another over to her equally naked companion beside her. Her guilt was then passed down to her descendants, and now all earthly human situations are likely to be difficult and pain-ridden because they are the work of a corrupt and faulty human spirit.

This odd idea is obviously not literally true. However, as a metaphor for why the world might be in a mess and life tricky, why we're constantly in difficulty and nothing is ever quite as it should be, it has a beguiling poetic truth to it, as relevant to atheists as believers.

We should perhaps not expect too much from ourselves or the human race more broadly, Augustine suggests. Things were beautiful back then, in that lovely garden, but they can no longer be so going forward, for some very ancient and deep-seated reasons. We're doomed from the outset; nothing we touch can be flawless. This isn't paradise. And that can, in certain moods, be a highly redemptive, even cheering thought to take the edge off feelings of persecution, weariness and responsibility.

Laura Stevens,
Lily from *Another November*, 2014

We never learn why Lily is crying. She's crying because she's human. She's crying as we cry: because we're lost and frightened, scared and abandoned, guilty and desperate. In other words, because we're human.

One of the wisest things about young children is that they have no shame about bursting into tears all the time, perhaps because they have a more accurate and less pride-filled sense of their place in the world: they know they are extremely small beings in a hostile and unpredictable realm. Why not then, on a fairly regular basis, collapse into sobs at the sheer scale of the sorrow of being alive?

Unfortunately, such wisdom tends to get lost as we age. We get taught to avoid being that most apparently repugnant (yet actually deeply philosophical) of creatures: the cry-baby. We start to associate maturity with a suggestion of invulnerability and competence. But this is the height of danger and bravado. Realising that we can no longer cope is an integral part of true endurance. We are in our essence and should always strive to remain cry-babies; that is, people who intim-ately remember their susceptibility to hurt and grief. Moments of losing courage belong to a brave life.

Despite our adult powers of reasoning, the needs of childhood constantly thrum within us. We are never far from craving to be held and reassured, as we might have been decades ago by a sympathetic adult, most likely a parent, who made us feel physically protected, kissed our forehead, looked at us with benevolence and tenderness and perhaps said not much other than, very quietly, 'Of course.' To be in need (as it were) of Mummy is to risk ridicule, especially when we are a couple of metres tall and in a position of responsibility. Yet to understand and accept our younger longings is the essence of genuine adulthood. There is no maturity without an adequate negotiation with the infantile; there is no such thing as a proper grown-up who does not frequently yearn to be comforted like a toddler.

Lily (whoever she is, and whatever she is suffering from) is doing us a huge favour; she's letting us know the honourable place of tears in a beautiful and good life.

Pieter Saenredam,
*The Interior of the Nieuwe Kerk, Haarlem,
seen from the south-west*, 1658

Pieter Saenredam was a 17th-century Dutch artist who adored calm, white, minimal interiors, mostly those of churches, of which he painted some twenty-five in his lifetime. A typical Saenredam interior has high ceilings, tall windows, a serene even light and a few distant figures somewhere in a corner or alcove talking in what we can imagine to be a murmur.

In its masterful exploration of a very narrow seam, Saenredam's work lends itself to a simple psychological enquiry. Why do certain people thrill to his paintings, with the emptiness and the quiet drawing them in and making them long powerfully? And why are many others left cold and even repulsed? Where is the reassuring clamour and bustle, they might ask; where are the colours; why is everything eerily dead?

What can explain our differences in taste is the idea of compensation. We are attracted to things visually that make up for what we're missing psychologically. Conversely, we are uninterested in elements we already have enough of or that burden our lives. The styles we love in art capture aspirations that are currently under-supported and that we long to bolster. It isn't that we are presently like the art we love; we just hope to become so.

To be moved by Saenredam's work is to register that there is too much going on in our lives, that we must simplify and purify our routines, that we need space to process what has happened to us, that we need to shut the door on more things.

We become more complete people when we learn to ask, of any artwork we love, what it might tell us about what is missing from our lives. Beauty isn't just a pleasing aesthetic response; it's a call to evolve in a certain direction in a search for contentment and completeness.

NASA,
Curiosity Self-Portrait at 'Glen Etive' site,
2019

This is a self-portrait by one of the greatest artists of the 21st century: a car-shaped contraption named Curiosity, which has been moving around at a glacial pace (it would take an hour to complete a 100-metre sprint) on the surface of Mars since its bumpy landing there in a cloud of dust on 6 August 2012 following a 560-million-kilometre journey from Earth.

Curiosity has ostensibly come to Mars to find out more about the planet's biological and geochemical properties. It has been trying to understand Mars' organic carbon compounds; it's been figuring out the relative proportions of sulphur, carbon, hydrogen and phosphorus in the atmosphere. It's been mapping isotopic composition and measuring the spectrum of radiation, with a special interest in secondary neutrons and solar proton events.

But whatever the stated purpose, what Curiosity has really been trying to do is to help our marriages, calm our anger with our colleagues, appease our disappointments and bolster our capacities for calm and perspective. No one can look at any of the images it has sent back without a sense of awe that at once relativises everything petty and regrettable that agitates and demeans us day to day.

What can it possibly matter who said what to whom and in what voice, given that Curiosity has captured the sun going down at six in the evening below the rim of Gusev Crater? Or that its mast camera has just sent thirty-two individual images that it has assembled into a panorama of a Martian outcrop nicknamed Mont Mercou?

The machine also reminds us of the beauty of our own planet. The bleakness of Mars emphasises the lushness of our own world; pictures of this far-off place we will probably never go to ourselves can inspire wonder and gratitude for where we are already.

Like all great artists, and with comparable technical ingenuity, Curiosity has attempted to help us change our lives, away from superficiality and bitterness and towards goodness, wisdom and truth.

Eugène Atget,
Boutique Fleurs, rue de Vaugirard,
c. 1923–1924

It looks ostensibly like a photograph of a flower shop, but Eugène Atget has also produced something far more solemn, melancholy and significant: a funeral ode. There might as well be a coffin below those blooms – and we are in it. Celosias, gladioli, lilacs, magnolias, sweet peas and zinnias – all flourished with particular vigour one midmorning in Paris in the early summer of 1923, but none could evade the laws of entropy. They, the flower shop, its owners, the 20-year-old freckled assistant from Clermont-Ferrand who wrapped things up with such care, Atget, a whole generation – all have gone. The display defiantly celebrates life but simultaneously alludes to the remorse-less massacres of time. Nothing survives; it's coming for us just like it came for them.

Through their ability to summon with exceptional vigour the texture of one very specific moment, photographs necessarily intimate the moment's cruel subsequent disappearance into the jaws of death. That is why century-old photographs of young children, especially when they are seized in a carefree mood, playing with the cat or spraying themselves with the garden hose, are invariably tainted with tragedy. We're looking at imminent old men and women who, after a lifetime of the usual measures of pain and regret, became skeletons. Through Atget's lens, a scene becomes wholly present in its innocent glory, only to be returned to the darkness to which we are all bound. We might take a picture of almost anything, however clumsily framed – today's sandwich, the light striking the garden wall, our 3-year-old drawing Mummy – then bury it for a hundred years and its sight would leave our successors in tears.

In theory, we know that we are going to die. But a gulf exists between a fact and its resonant absorption. We waste a lot of time as a result, because it is only when passivity ends and real fear starts that we gain the courage and urgency to get on with the truly daunting challenges of the remainder of our lives. The purpose of art is to find new and freshly forceful ways of keeping the most important mortal thoughts constantly at the front of our minds: to turn a flower shop into a hearse.

Copies of Vincent van Gogh's
The Starry Night, Dafen, China, 2014

Vincent van Gogh's 1889 painting *The Starry Night*, owned by the Museum of Modern Art in New York, is one of the most expensive paintings in the world. But in Dafen, in China's Guangdong Province, you can pick up a hand-painted copy for as little as forty dollars.

Sometimes, of course, a copy is truly terrible. It mucks up the details, it gets proportions weirdly wrong. But not always; in many cases, you couldn't tell it apart from the original unless you used a microscope.

But still our cultural industries sneer. However, this has everything to do with their mercantile need to preserve the value of their assets and nothing to do with our own interior benefit. When we are told that art inherently belongs in galleries, we are being condemned to encountering works only at times dictated by museum schedules, which means that we miss out on most of what art can actually do for us.

We hardly ever get enraged and want to curse in MoMA, so we're unlikely ever to have direct need of van Gogh's immensely calming nocturnal vista when we see it. The place we really need those stars and that swirling moon is in the kitchen or the bathroom at home after a long day, the places where we shout at the children and say things we shouldn't to our spouse.

Artworks have therapeutic power that passes us by not because we are insensitive or unworthy, but for a more basic reason: their messages hit us at the wrong time, at moments when we've no need of them, like adverts for winter coats on the first day of spring.

Copying is the much-needed solution, because it allows us to place important, beneficial images in exactly the places where we need them. We are negative about copying because we're not so sure what we really want from art. The real point of art isn't to do with enriching owners; it is to help us live our lives more wisely and with greater poise. Once we recognise this great and practical purpose, we become less bothered by the difference between an original and a copy because we can accept that a copy – even one in a book – will be just as effective at getting us through till morning.

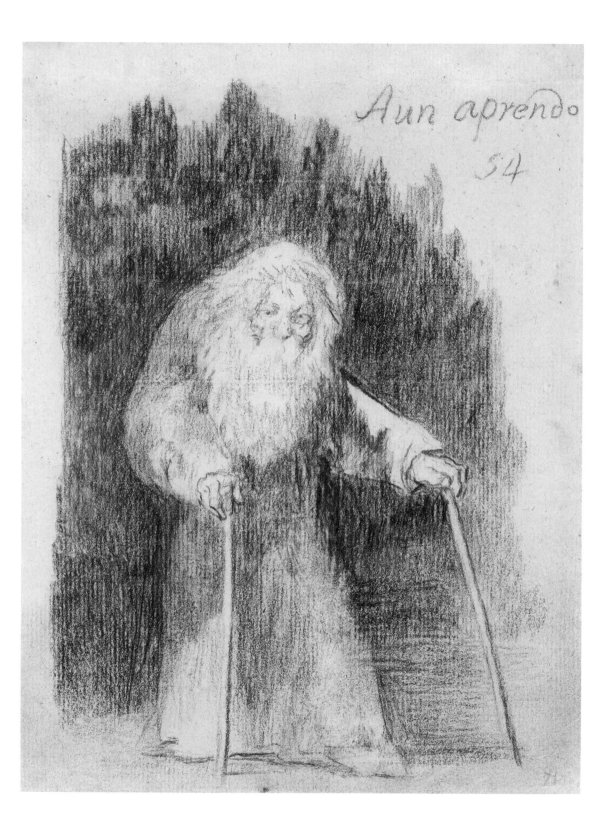

Francisco Goya,
I Am Still Learning, c. 1826

When Spain's greatest painter completed this drawing circa 1826, he was over 80 and had only two years left to live. He was almost totally deaf, his eyesight was failing and he couldn't walk unaided. But he had not given up. He was still making great art, travelling, being read to, deepening his friendships and, most of all, looking. Despite everything, as he wrote with heartbreaking defiance at the top of the page: *'Aun aprendo'* (I am still learning).

What was he still learning? Not so much about art; he knew most of what there was to know in that field. He was learning the ostensibly simple but always elusive lessons that life insists on: about forgiveness, the importance of courage, the need to appreciate the beauty of the world, saying yes again and again to the universe despite its horrors, making time for small children, the beauty of lemons and olives and the tenderness of dusk.

Such lessons are never complicated in themselves. It's the remembering and the feeling that's hard. Great art strives to convince us of what are, intellectually, very basic things: love today, don't lose yourself to grudges, don't feel singled out by sadness, let joy overwhelm you, don't be afraid, resist bitterness, care less of what others think.

The aged, hobbit-like Goya advancing towards us on his sticks has a twinkle in his eye. He is indomitable. He has come out of bed, even though cautious voices told him not to, because he wants another look at the world. There's a park he wants to visit, there's a bookshop he's heard about, there's a friend he wants to see. Death may be calling, but he won't listen. He is ancient, he can't walk straight, he winces in pain, but he retains the curiosity and energy of his very young self.

We have wasted a lot of time. We have refused to learn so much and on so many occasions. We have been flighty, stubborn, blinkered, dull and hard-hearted. But our spirit isn't vanquished, which is why we're here. There are so many pictures left to see and ideas to recall and rehearse.

It wasn't too late for him – and it isn't too late for us.

Picture credits

p. 6 Henri Cartier-Bresson, *New York City, Brooklyn, 2nd Avenue, A café*. 1947 © Henri Cartier-Bresson © Foundation Henri Cartier-Bresson / Magnum Photos

p. 8 Francisco Goya, *The Sleep of Reason Produces Monsters* (no. 43), from *Los Caprichos*, 1799. Etching with aquatint, 18.8 cm x 14.9 cm. The Metropolitan Museum of Art, New York, USA

p. 10 Ad Reinhardt, *Abstract Painting*, 1963. Oil on canvas, 152.4 cm x 152.4 cm © 2021 Estate of Ad Reinhardt / Artists Rights Society (ARS), New York. © ARS, NY and DACS, London 2021 / 143.1977 © 2021. Digital image, The Museum of Modern Art, New York / Scala, Florence

p. 12 Jim Goldberg, *Untitled*, 1983. Gelatin silver print, 35.2 cm × 27.6 cm © 2021 Jim Goldberg / Magnum Photos

p. 14 Alec Dawson, *Nobody Claps Any More*, 2014 © Alec Dawson

p. 16 Robert Adams, *Longmont, Colorado* from *What We Bought: The New World, Scenes from the Denver Metropolitan Area*, 1970-1974 © Robert Adams, courtesy Fraenkel Gallery, San Francisco

p. 18 Edgar Degas, *Family Portrait*, 1858-1869. Oil on canvas, 200 cm x 250 cm. Musée d'Orsay, Paris, France. Photo © Photo Josse / Bridgeman Images

p. 20 Cy Twombly, *Untitled*, 1954. Gouache, crayon and coloured pencil on paper, 48.3 cm × 63.2 cm, The Judith Rothschild Foundation

Contemporary Drawings Collection Gift (by exchange). Given in honour of Kathy Fuld. Acc. no.: 83.2016. © 2021. Digital image, The Museum of Modern Art, New York / Scala, Florence © 2021 Cy Twombly Foundation

p. 22 Étienne-Jules Marey, *The Running Jump*, 1882. Science History Images / Alamy Stock Photo

p. 24 Gustave Caillebotte, *Rooftops in the Snow*, 1878. Oil on canvas, 64 cm x 82 cm. Musée d'Orsay, Paris, France. Archivart / Alamy Stock Photo

p. 26 Louise Bourgeois, *The Insomnia Drawings* (detail), 1994-1995. One of 220 mixed media works on paper of varying dimensions © The Easton Foundation / VAGA at ARS, NY and DACS, London 2021. Photo: Christopher Burk

p. 28 Drinking glass, from Venice, Italy, c. 1550-1650. Colourless, free-blown and pattern-moulded cristallo glass, 19.2 cm x 9.5 cm. Los Angeles County Museum of Art, Los Angeles, USA

p. 30 Giotto, crying angels, detail from the *Lamentation of Christ*, 1305. Fresco, 200 cm x 185 cm. Scrovegni Chapel, Padua, Italy. Artefact / Alamy Stock Photo

p. 32 Roman votives, 2nd-3rd century BCE. Image courtesy www.HolyLandPhotos.org

p. 34 Édouard Vuillard, *In Bed*, 1891. Oil on canvas, 74 cm x 92 cm. Musée d'Orsay, Paris, France. The Artchives / Alamy Stock Photo

p. 36 Claude Monet, *Boat at Low Tide at Fecamp*, 1881. Oil on canvas, 82 cm x 60 cm. Tokyo Fuji Art Museum, Hachiōji, Tokyo, Japan. incamerastock / Alamy Stock Photo

p. 38 William Playfair, *Exports and Imports of Scotland to and from different parts for one Year from Christmas 1780 to Christmas 1781,* from *The Commercial and Political Atlas,* 1786 (3rd edition, 1801) / Wikimedia Commons

p. 40 Gail Albert Halaban, *Paris, Out of My Window,* 2012 © Gail Albert Halaban

p. 42 John Lund, *Tanker in Ocean Storm*, 2019. John Lund / Getty Images

p. 44 Constantin Brâncuși, *The Beginning of the World*, 1924. Bronze, 16.5 cm × 28.5 cm × 15.5 cm. Kröller-Müller Museum, Otterlo, Netherlands. © Succession Brâncuși - all rights reserved. ADAGP, Paris and DACS, London 2021

p. 46 Hiroshi Yoshida, *Kumoi Cherry Trees*, 1926. Woodblock print; ink and colour on paper, 58.7 cm x 74.4 cm. Museum of Fine Arts Boston, Boston, USA. Asiatic Curator's Fund / Bridgeman Images

p. 48 Jules Germain Cloquet, *The Digestive Tract*, Plate 297 from the *Manuel d'anatomie descriptive du corps humain*, 1825 © Royal College of Physicians

p. 50 Rania Matar, *Izzy, Brookline, Massachusetts* from *A Girl and Her Room*, 2009 © Rania Matar

p. 52 Robert Rauschenberg, *Automobile Tire Print*, 1953. Monoprint: house paint on 20 sheets of paper, mounted on fabric, 41.9 cm x 671.8 cm. Purchase through a gift of Phyllis C. Wattis. © Robert Rauschenberg Foundation. RRF Registration # 53.E001 / VAGA at ARS, NY and DACS, London 2021

p. 54 Cuno Amiet, *Snowy Landscape (Deep Winter)*, 1904. Oil on canvas, 178 cm x 235 cm. Musée d'Orsay, Paris, France. Photographer: Hervé Lewandowsk. © 2021. RMN-Grand Palais / Dist. Photo SCALA, Florence

p. 56 Thomas Gainsborough, *The Painter's Daughters with a Cat*, c. 1760-1761. Oil on canvas, 75.6 cm x 62.9 cm. National Gallery, London, England / Wikimedia Commons

p. 58 Gustave Caillebotte, *View Seen Through a Balcony*, 1880. Oil on canvas, 65.6 cm x 54.9 cm. Van Gogh Museum, Amsterdam, Netherlands. Purchased with support from the BankGiro Loterij, the Vincent van Gogh Foundation, the Mondriaan Fund, the Rembrandt Association, partly thanks to the Prins Bernhard Cultuurfonds, and the VSBfonds / Wikimedia Commons

p. 60 Thomas Struth, *Musée du Louvre IV, Paris, 1989*, 1989. Colour photograph, 180 cm x 214 cm. ZKM, Centre for Art and Media Karlsruhe, Karlsruhe, Germany © Thomas Struth

p. 62 Félix Vallotton, *The Great Cloud*, 1900. Oil on cardboard, 35 cm x 46 cm, Musée cantonal des Beaux-Arts, Lausanne, Switzerland © Musée cantonal des Beaux-Arts de Lausanne

p. 64 Jean-Baptiste Regnault, *The Origin of Painting*, 1786. Oil on canvas, 120 cm x 140 cm. Inv: MV7278. Photographer: Gérard Blot. Versailles, Chateaux de Versailles et de Trianon. © 2021. RMN-Grand Palais / Dist. Photo SCALA, Florence

p. 66 Gwen John, *A Corner of the Artist's Room in Paris*, 1907-1909. Oil on canvas, 31.2 cm x 24.8 cm © Estate of Gwen John 2022

p. 68 Peder Severin Krøyer, *Roses*, 1893. Oil on canvas, 67.5 cm x 76.5 cm. Skagens Museum, Skagen, Denmark / Bridgeman Images

p. 70 Prayer niche (mihrab), from Isfahan, Iran, c. 1500s. Ceramic mosaic, 290.7 cm x 245.3 cm. The Cleveland Museum of Art, Cleveland, USA. Gift of Katharine Holden Thayer 1962.23. Artokoloro / Alamy Stock Photo

p. 72 William Scott, *Still Life*, 1973. Screenprint on paper, 67.3 cm × 88.9 cm. Tate Museum, London, England © Estate of William Scott 2022 / courtesy Tate Images

p. 74 Daniel Spoerri, *Variations d'un petit déjeuner*, 1966. Assemblage, mixed media, 31 cm x 47 cm. Collection Pictet, Switzerland. © DACS 2021

p. 76 Wayne Thiebaud, *Cakes*, 1963. Oil on canvas, 152.4 cm x 182.9 cm. Gift in honor of the 50th anniversary of the National Gallery of Art from the Collectors Committee, the 50th Anniversary Gift Committee, and The Circle, with additional support from the Abrams family in memory of Harry N. Abrams / National Gallery of Art, Washington, USA. 1991.1.1. © Wayne Thiebaud / VAGA at ARS, NY and DACS, London 2021

p. 78 Stephen Shore, *Breakfast, Trail's End Restaurant, Kanab, Utah, August 10, 1973*, 1973. Chromogenic colour print, 22.9 cm x 28.3 cm. Digital image: The Museum of Modern Art, New York, USA / Scala, Florence

p.80 Antonio da Correggio, *The Holy Night*, c. 1528-1530. Oil on panel, 256.5 cm x 188 cm. Gemäldegalerie Alte Meister, Dresden, Germany © Staatliche Kunstsammlungen Dresden / Bridgeman Images

p. 82 John Ruskin, *Enlarged Studies of the Feathers of a Kingfisher's Wing and Head, and a Study of a Group of the Wing Feathers, real size*, c. 1871. Watercolour and bodycolour over graphite on wove paper, 37.5 cm x 25 cm. Ashmolean Museum, Oxford, England © Ashmolean Museum / Bridgeman Images

p. 84 Émile-Antoine Bayard and Alphonse de Neuville, illustration from Jules Verne's *From the Earth to the Moon*, 1865. Wood engraving. World History Archive / Alamy Stock Photo

p. 86 Slim Aarons, *Sarah Marson Williams enjoys a cocktail on the beach at the Hilton Hotel, Needhams Point, Barbados, April 1976*, 1976. Slim Aarons / Hulton Archive / Getty Images

p. 88 Ferdinand Hodler, *Dents du Midi from Champéry*, 1916. Oil on canvas, 51 cm x 75 cm. Nestlé Art Collection. Heritage Image Partnership Ltd / Alamy Stock Photo

p. 90 Félix Vallotton, *The Ball (Corner of the Park with Child Playing with a Ball)*, 1899. Oil on card glued on wood, 48 cm x 61 cm. Musée d'Orsay, Paris, France / Wikimedia Commons

p.92 Winston Churchill, *Still Life, Fruit*, c. 1930s. Oil on canvas, 25 in x 30 in. Heather James Gallery, San Francisco, USA / courtesy Heather James Fine Art

p. 94 Burt Glinn, *Japan, Kyoto, 1961. A monk arranges sand patterns in the rock garden of Nanzenji Temple*, 1961 © Burt Glinn / Magnum Photos

p. 96 Nicolaes Maes, *Young Woman Peeling Apples*, c. 1655. Oil on wood, 54.6 cm x 45.7 cm. The Metropolitan Museum of Art, New York, USA

p. 98 Jacobus Vrel, *Woman at a Window, Waving at a Girl*, c. 1650. Oil on panel, 45.7 cm x 39.2 cm. Fondation Custodia, Paris, France / Wikimedia Commons

p. 100 Nicolaes Maes, *The Naughty Drummer*, 1655. Oil on canvas, 62 cm x 66.4 cm. Museo Nacional Thyssen-Bornemisza, Madrid, Spain / Wikimedia Commons

p. 102 Julia Fullerton-Batten, *The Rehearsal*, 2012. © Julia Fullerton-Batten. The text is the author's interpretation of the photograph and should not be considered a literal description of the relationship between the individuals depicted.

p. 104 Joel Meyerowitz, *New York City, 1963*, 1963 © Joel Meyerowitz, courtesy Howard Greenberg Gallery

p. 106 Natalie McComas, *Five-year old Ryan's superhero party. Eighteen children attended the party for three hours. Total cost of party: $100*, from *Birthday Wishes*, 2006 © Natalie McComas

p. 108 Raymond Depardon, *Glasgow, Scotland*, 1980 © Raymond Depardon / Magnum Photos

p. 110 William Steig, *"How do you spell 'hate'?"*, c. 1960s. Pen and ink and wash on paper, 22.9 cm x 25.4 cm

p. 112 Edward Gorey, illustration from *The Doubtful Guest*, 1958

p. 114 Alec Dawson, *Nobody Claps Anymore*, 2014 © Alec Dawson

p. 116 Hans Baldung, *Woodcut of Aristotle ridden by Phyllis*, 1515. Woodcut, 32.7 cm x 23.5 cm. Heritage Image Partnership Ltd / Alamy Stock Photo

p. 118 Lucian Freud, *Strawberries*, 1952. Oil on copper, 10.2 cm x 12.1 cm. English, private collection © The Lucian Freud Archive. All rights reserved 2022 / Bridgeman Images

p. 120 William Hogarth, *Marriage A-la-Mode: 1, The Marriage Settlement*, 1743. Oil on canvas, 70 cm x 91 cm. National Gallery, London, England / Bridgeman Images

p. 122 David Hurn, *Coach party from the valleys on holiday during the fortnight close down of the pits, Aberavon Beach, Wales*, 1971 © David Hurn / Magnum Photos

p. 124 Richard Learoyd, *Tatiana on Mirror*, 2010. © Richard Learoyd, courtesy Fraenkel Gallery, San Francisco

p. 126 Little Tommy Tittlemouse, owned by James Gowan (1907-1986), manufactured in Germany, c. 1908 © Victoria & Albert Museum, London

p. 128 Garry Winogrand, *Los Angeles International Airport*, 1964. Gelatin silver print, 34 cm × 22.7 cm. © The Estate of Garry Winogrand, courtesy Fraenkel Gallery, San Francisco

p. 130 Jan Steen, *The Sleeping Couple*, c. 1658-1660. Oil on copper, Dutch Guildhall Art Gallery, City of London © Guildhall Art Gallery / Harold Samuel Collection / Bridgeman Images

p. 132 George Thames, *William Masters and Virginia Johnson interviewing a couple at the Reproductive Biology Research Foundation, St Louis, Missouri*, 1969 © George Thames / The New York Times / Redux

p. 134 Timothy Archibald, *Dan and Jan* from *Sex Machines: Photographs and Interviews*, 2005 © Timothy Archibald

p. 136 Garry Winogrand, *Opening, "New York Painting and Sculpture, 1940-1970", Metropolitan Museum of Art, New York*, 1969. © The Estate of Garry Winogrand, courtesy Fraenkel Gallery, San Francisco

p. 138 Nuna peoples, carved hawk's mask, southern Burkina Faso. Millard H. Sharp / Science Source / Science Photo Library

p. 140 Martine Franck, *France, Hauts de Seine, "Maison de Nanterre", old people's house*, 1978 © Martine Franck / Magnum Photos / © DACS 2021

p. 142 Bernhard Lang, *Adria*, 2014. Photography Bernhard Lang

p.144 Peter Paul Rubens, *The Three Graces*, 1630-1635. Oil on wood panel, 220.5 cm x 182 cm. Museo Nacional del Prado, Madrid, Spain. Image Copyright Museo Nacional del Prado © Photo MNP / Scala, Florence

p. 146 Sandro Botticelli, *The Mystical Nativity (detail)*, 1500. Oil on canvas, 108.6 cm x 74.9 cm. National Gallery, London, England / Wikimedia Commons

p. 148 Henry Moore, from *The Sheep Sketchbook*, 1972. Reproduced by permission of The Henry Moore Foundation

p. 150 Johannes Vermeer, *The Milkmaid*, c. 1660. Oil on canvas, 45.5 cm x 41 cm. Rijksmuseum, Amsterdam, Netherlands

p. 152 Jacob van Ruisdael, *The Windmill at Wijk bij Duurstede*, c. 1670. Oil on canvas, 83 cm × 101 cm. Rijksmuseum, Amsterdam, Netherlands

p. 154 Mary Cassatt, *The Young Mother (Mother Berthe Holding Her Baby)*, 1900. Pastel on paper, 57.1 cm x 45 cm. Photo © Christie's Images / Bridgeman Images

p. 156 Samuel Luke Fildes, *The Village Wedding*, 1883. Oil on canvas, 151.8 cm x 255.3 cm. Private collection © Christopher Wood Gallery, London, UK / Bridgeman Images

p. 158 Georgia O'Keeffe, *Untitled (Hand)*, c. 1902. Graphite on paper, 6.5 in x 9.25 in. Georgia O'Keeffe Museum, Santa Fe, USA © Georgia O'Keeffe Museum © 2021. Photo Georgia O'Keeffe Museum, Santa Fe / Art Resource / Scala, Florence. © Georgia O'Keeffe Museum / DACS 2022

p. 160 Philippe Halsman, *Marilyn Monroe reading in her apartment*, 1952. Photo © Philippe Halsman / Magnum Photos / © DACS 2021

p. 162 Spencer Gore, *Interior*, 1910. Photo credit: Fife Council

p. 164 Allan Douglas Davidson, *She (The Blushing Girl)*, 1930. Oil on panel, 24 cm x 17 cm. The Wroxham Art Gallery, Wroxham, England. Photo © The Maas Gallery, London / Bridgeman Images

p. 166 Govardhan, *A Discourse between Muslim Sages*, c. 1630. Opaque watercolour, gold, silver and ink on paper, 20.8 cm x 13.34 cm. Los Angeles County Museum of Art, Los Angeles, USA / Wikimedia Commons

p. 168 Robert Adams, *Longmont, Colorado* from *What We Bought: The New World, Scenes from the Denver Metropolitan Area,* 1974 © Robert Adams, courtesy Fraenkel Gallery, San Francisco

p. 170 Luis Velasco, *Back of an Anonymous Scientist Working in a Laboratory*, 2021. Luis Velasco / Stocksy

p. 172 Chien-Chi Chang, *Thailand, Bangkok International Airport*, 2012 © Chien-Chi Chang / Magnum Photos

p. 174 Robert Adams, *Untitled (potato chips)* from *What We Bought: The New World, Scenes from the Denver Metropolitan Area*, 1970–1974 © Robert Adams, courtesy Fraenkel Gallery, San Francisco

p. 176 Abbas, *India, 5, Rajasthan, near Bundi, section of a highway being constructed*, 2016 © A. Abbas / Magnum Photos

p. 178 Lucas Cranach the Elder, *The Fountain of Youth*, 1546. Oil on canvas, 186.1 cm × 120.6 cm. Gemäldegalerie, Berlin, Germany / Wikimedia Commons

p. 180 Rembrandt van Rijn, *The Woman Taken in Adultery*, 1644. Oil on oak wood, 83.8 cm x 65.4 cm. National Gallery, London, England

p. 182 Associated Press, *A 15-year-old girl emboldens her fellow Red Guards during the Cultural Revolution*, 1966. AP Photo

p. 184 Rogier van der Weyden, Archangel Michael weighing souls from *The Beaune Altarpiece* (detail), 1445–1450. Oil on wood, 220 cm × 109 cm / Bridgeman Images

p. 186 William Hodges, *Tahiti Revisited*, 1776. Oil on canvas, 92.7 cm x 138.4 cm. National Maritime Museum, Greenwich, London

p. 188 Jan Brueghel the Elder, *Adam and Eve in the Garden of Eden*, 1615. Oil on copper, 48.6 cm x 65.6 cm. Royal Collection Trust, London, England / Wikimedia Commons

p. 190 Laura Stevens, *Lily* from *Another November*, 2014. © Laura Stevens

p. 192 Pieter Saenredam, *The Interior of the Nieuwe Kerk, Haarlem, seen from the south-west*, 1658. Oil on panel, 30.5 cm x 31 cm. Private collection / Wikimedia Art

p. 194 NASA, *Curiosity Self-Portrait at 'Glen Etive' site*, 2019. NASA / JPL-Caltech / MSSS

p. 196 Eugène Atget, *Boutique Fleurs, rue de Vaugirard*, c. 1923–1924. Matte albumen silver print, 22 cm × 18 cm. Abbott-Levy Collection. Partial gift of Shirley C. Burden. Acc. no.: 1.1969.2393. New York, Museum of Modern Art (MoMA). © 2021. Digital image, The Museum of Modern Art, New York / Scala, Florence. All rights reserved, DACS 2021

p. 198 Copies of Vincent van Gogh's *The Starry Night*, Dafen, China, 2014. Tuul and Bruno Morandi / Alamy Stock Photo

p. 200 Francisco Goya, *I Am Still Learning*, c. 1826. Artefact / Alamy Stock Photo

The School of Life is a global organisation helping people lead more fulfilled lives. It is a resource for helping us understand ourselves, for improving our relationships, our careers and our social lives – as well as for helping us find calm and get more out of our leisure hours. We do this through films, workshops, books, apps, gifts and community. You can find us online, in stores and in welcoming spaces around the globe.